Weaving Alliances with Other Women

Mercer University Lamar Memorial Lectures No. 55

Weaving Alliances with Other Women

꙳ ꙳ ꙳ ꙴ ꙴ ꙴ

Chitimacha Indian Work in the New South

DANIEL H. USNER

The University of Georgia Press
Athens and London

Set in 10.75/14 Chaparral Pro by
Melissa Bugbee Buchanan
Printed and bound by Thomson-Shore
The paper in this book meets the guidelines for
permanence and durability of the Committee on
Production Guidelines for Book Longevity of the
Council on Library Resources.

Most University of Georgia Press titles are
available from popular e-book vendors.

Printed in the United States of America
15 16 17 18 19 P 5 4 3 2 1

Library of Congress Cataloging-in-Publication Data
Usner, Daniel H.
Weaving alliances with other women : Chitimacha Indian
work in the new South / Daniel H. Usner.
pages cm
Includes bibliographical references and index.
ISBN 978-0-8203-4848-3 (hardcover : alkaline paper) —
ISBN 978-0-8203-4849-0 (paperback : alkaline paper) —
ISBN 978-0-8203-4847-6 (ebook)
1. Paul, Christine Navarro, 1874–1946. 2. Chitimacha Indians—Biography.
3. Indian women basket makers—Louisiana—Biography. 4. Paul,
Christine Navarro, 1874–1946—Friends and associates. 5. Bradford, Mary
McIlhenny, 1869–1954. 6. Dormon, Caroline, 1888–1971. 7. Chitimacha
Indians—Social conditions—20th century. 8. Female friendship—Social
aspects—Louisiana—History—20th century. 9. Whites—Louisiana—
Relations with Indians—History—20th century. 10. Louisiana—
Race relations—History—20th century. I. Title.
E99.C7U87 2015
305.897'90763—dc23
2015003593

British Library Cataloging-in-Publication Data available

For

Aline Usner Celestin and Warren A. Usner

❧ CONTENTS ❦

On an unpaginated sheet in an undated notebook, Caroline Dormon wrote, "Must meet Mrs. Sidney Bradford, Avery Island."[1] There is no evidence that Dormon ever met Bradford, although the long lives of these two Louisiana women overlapped by nearly sixty years. Mary McIlhenny Bradford belonged to one of south Louisiana's most prominent families, living in a large house near the Gulf Coast and traveling to New Orleans frequently for family visits and social events. Caroline Dormon lived in a small cabin deep within north Louisiana's longleaf pine forest, earning a middle-class income through pursuit of various occupations. But the cause of Dormon's unfulfilled instruction to herself was a Chitimacha Indian woman named Christine Paul, living a much harder life than theirs in her crowded home along moss-draped Bayou Teche. This book will introduce the reader to these three very different southern women, whose lives were woven together by the things that Christine Paul and other Chitimacha women wove with their hands—beautiful baskets made of river-cane splints dyed with walnut and dock root and twilled into complex patterns.

Since an American Indian woman—befriended by two white women who never met each other—is the central character in all three of my chapters, it is worth remembering what Clara Sue Kidwell wrote two decades ago: "The mythology of Indian women has overwhelmed the complexity of their roles in the history of Indian and white contact."[2] Thanks to growth in scholarship since then, we now know how Indian women innovatively deployed kinship and networking strategies to help mitigate disruptive and destructive effects of white domination. As mediators between their own communities and surrounding outsiders, they often-

times drew upon accumulated authority and experience in multi-cultural negotiation to forge new relationships with other women that could facilitate adaptation in face of threatening change. The slightest overlap between ideals of womanhood, as Lucy Murphy shows for Indian and Métis women in the Great Lakes region, offered them some chance of protecting or even advancing their communities' interests.[3]

Friendships that Christine Paul (1874–1946) sustained with Mary Bradford (1869–1954) and Caroline Dormon (1888–1971) at different times in her life offer an all too scarce vantage point from which to explore the condition of American Indians in the Jim Crow South. "Aspects that, for the most part, have not been addressed in historical works" according to Devon Mihesuah, "are the feelings and emotions of Native women, the relationships among them, and their observations of non-Natives." In this book I hope to overcome this neglect for one Indigenous community in the southern United States. In Christine Paul's respective exchanges of information and insight with two white patrons, thanks to the survival of her invaluable correspondence with Bradford and Dormon, I found what Rebecca Sharpless called a "bivocal representation" of relationships fraught with important social, economic, and cultural tensions.[4] Interacting closely within a social web largely woven with woven objects, the identities of these three women nonetheless developed along very separate paths—paths mapped out by their unequal positions in the New South.

By offering biographical sketches of Mary Bradford, Christine Paul, and Caroline Dormon in the chapters that follow, I seek in the guiding words of Nick Salvatore to examine "the process of historical change through an individual who, like other humans, grapples simultaneously with complex forces both public and private." And like Salvatore, I have discovered that this endeavor demands a broader and more extensive research strategy than one might expect. The "faintest inference" detected in the sources can lead the historian onto unexpected paths of inquiry and wonder, becoming as Rebecca Solnit aptly puts it "the point of entry to larger territories."[5] This biographical approach also allows me to bridge

what was once prized as "new social history" with what is now celebrated as "new cultural history." How the production of language and imagery actually subjected people to one kind of "otherness" or another is perhaps best understood when examined as the lived experience of those engaged on all sides of the process.[6]

Because the lives of Mary Bradford, Christine Paul, and Caroline Dormon intersected largely through a flow of material objects, this book owes much to the sprawling field of material culture studies. The movement of items across cultural boundaries is particularly relevant to this interdisciplinary scholarship on the early twentieth-century circulation of Chitimacha baskets. Study of American Indians in the early South, for example, has benefited greatly from close attention to the intercultural exchange of objects. Indigenous peoples turned European objects into prestige goods in order to stabilize endangered political systems, while European colonizers turned tens of thousands of Indigenous people into enslaved commodities. The profound impact of European trade goods on American Indian societies has long been recognized, but now we also realize the high value of deerskins and other commodities that Indian people contributed to southern colonies' Atlantic world commerce. And we cannot overlook the even deeper influence of Indigenous foods and foodways on the region's cuisine. Over the nineteenth and twentieth centuries, we see material objects used in new contexts and circulating through different networks. As the expanding plantation economy undermined and displaced preexisting forms of Indigenous livelihood and exchange, Indian communities came to rely on niche marketing of specialized items such as traditional handicrafts, fish and game, or medicinal and food plants. Tourism in some parts of the South or arts and crafts promotion in others perpetuated to the present day an association of Indian identity with the sale of their cultural objects.[7]

The circulation of Chitimacha baskets far and wide in the early twentieth century, mainly driven by aesthetic and anthropological interests, demonstrates not only the persistence of ancient weaving skills in a single community but also the complexity of relations between Indians and non-Indians in the New South.

As Daniel Miller has emphasized, "Social relations exist in and through our material worlds that often act in entirely unexpected ways that cannot be traced back to some clear sense of will or intention." Objects do not simply reflect meaning or identity—in the way anthropologists once insisted upon a fixed symbolism in things such as baskets—but their materiality in itself carries agency and potential in social life.[8] Cultural identities and political positions can be negotiated through the production and distribution of things, as multiple purposes and incongruent meanings circulate through the market. Although the exotic appeal of cultural objects obscured, even threatened to erase, the modern interaction actually occurring between Indian artists and non-Indian consumers, Chitimacha basketmakers saw in the narrow interest shown by friendly outsiders a means of protection against hostile outsiders, hopefully validating and preserving their autonomy in the midst of crisis. Indigenous art, as Jolene Rickard reminds us, has for a long time been integral to the strategic work of negotiating territory and sovereignty in Native America. "Visual expressions of Indigenous artists," she writes, "are as crucial to the sovereigntist's agenda as legal reform is within the debate."[9]

In Christine Paul's determination both to promote the basketry tradition and to protect the Chitimacha tribe, she also effectively used her ability to read and write English—a literacy that was still uncommon within a community for which French had already replaced Chitimacha as the primary spoken language. The English language in written form during this period, as Mindy Morgan has so carefully explained, was an instrument used by assimilationists to control and transform Indian people—with long-lasting effects upon Indigenous views of literacy even in Native languages—but it was nonetheless deployed by many American Indian leaders to combat exploitation and even alter government policy.[10] For Christine Paul, writing letters to nearby patrons and distant officials generated a flow of documentation that—as with the circulation of Chitimacha baskets—became another material representation, an archive of American Indian livelihood, identity, and self-determination. This feature of her alliance-weaving strategy

serves to remind historians that written documents and archival sources are themselves material objects that our own craft transforms into historical texts. Whatever can be found of any correspondence written by Indian women and men, on behalf of communities too often under duress, constitutes a body of Indian work that historians cannot afford to overlook.[11]

Making possible my own venture into an archive created by one American Indian woman was the fortuitous discovery, underneath the stairs of Mary McIlhenny Bradford's house on "Happy Hill," of a small wooden box stuffed with letters and other documents related to her Indian work. In the early spring of 2008, Lisa Osborn—a great-granddaughter of Edward A. McIlhenny and great-grand-niece of Bradford (Osborn also is a sensational sculptor)—began restoration of this abandoned building on Avery Island, Louisiana, as a new home for her family. She brought the box to McIlhenny Company archivist Shane Bernard, who immediately thought its contents might be of interest to me. I had visited the McIhenny archives the previous summer to examine miscellaneous material for what was originally intended to be an overall study of the region's American Indian peoples in the nineteenth and early twentieth centuries. Thanks to permission granted by the late Paul McIlhenny, then CEO and President of the Tabasco sauce company, my spouse Rhonda and I rushed to Avery Island and began the process of identifying and sorting hundreds of items, mostly correspondence that Bradford had received from dealers, anthropologists, curators, and collectors and—most remarkably and importantly—at least one hundred letters written by Christine Paul. With every historian's fantasy now made real for me, I made subsequent trips to Avery Island to obtain a full picture of Christine Paul's relationship with Mary Bradford and of the latter's network of communication with other basket enthusiasts. Paul's later correspondence with Caroline Dormon had already been available for some time in the Dormon Collection at Northwestern State University of Louisiana, so we now also have access to her words and actions as a younger woman. It has been a special pleasure and privilege for me to share my findings in

the McIlhenny Company archives with officials in the Chitimacha Tribe of Louisiana, and I hope someday soon to see historical and cultural studies produced by Chitimacha students from their own research.

Following the documentary trail of Chitimacha baskets, as anyone daring my dense endnotes will discover, took me to many other archives near and far. So here I would like to thank all staff members who assisted me at these research centers: Acadiana Manuscripts Collection, Edith Garland Dupré Library, University of Louisiana at Lafayette; American Philosophical Society, Philadelphia; Cammie G. Henry Research Center, Watson Library, Northwestern State University of Louisiana, Natchitoches; Catherine McElvain Library, School for Advanced Research, Santa Fe, New Mexico; Chitimacha Museum, Chitimacha Tribe of Louisiana, Charenton; Helen Farr Sloan Library and Archives, Delaware Art Museum, Wilmington; Historic New Orleans Collection, New Orleans; Historical Society of Pennsylvania, Philadelphia; The Huntington Library, San Marino, California; Interlibrary Loan Service, Jean and Alexander Heard Library, Vanderbilt University; James E. Walker Library, Middle Tennessee State University, Murfreesboro; Lauren Rogers Museum of Art, Laurel, Mississippi; Louisiana Research Collection, Howard-Tilton Memorial Library, Tulane University, New Orleans; Louisiana State University Museum of Natural Science, Baton Rouge; McIlhenny Company and Avery Island, Inc., Archives, Avery Island, Louisiana; National Archives, Washington, D.C.; Oklahoma Historical Society Research Center, Oklahoma City; Peabody Museum of Archaeology and Ethnology, Harvard University, Cambridge, Massachusetts; St. Mary Parish Records, Franklin, Louisiana. For funds covering the expenses of this widespread research, I owe gratitude to the Ethel-Jane Westfeldt Bunting Fellowship at the School for Advanced Research in Santa Fe, a Faculty Fellowship at Vanderbilt University's Robert Penn Warren Center for the Humanities, a Mayers Fellowship at The Huntington Library in San Marino, California, and most of all the Holland N. McTyeire Professorship at Vanderbilt University.

Individuals who deserve special thanks for their generous time and thoughtful help are Mary Linn Wernet (head archivist of the Cammie G. Henry Research Center), Shane Bernard (historian and archivist of the McIlhenny Company and Avery Island, Inc., Archives), Gray Osborn (grandnephew of Mary Bradford and Sara McIlhenny who has generously shared his reminiscences and researches with me), John Darden (chairman of the Chitimacha Tribe of Louisiana and acclaimed basket weaver), Kimberly Walden (cultural director of the Chitimacha Tribe of Louisiana), Rebecca Saunders (associate curator of anthropology at Louisiana State University's Museum of Natural Science), and Mercedes Whitecloud (advocate and friend of contemporary American Indian artists, who has been a constant source of encouragement and guidance since first assisting me with an exhibit on Louisiana Indians at the Historic New Orleans Collection years ago).

The invitation from the Southern Studies Program at Mercer University to deliver the Fifty-Sixth Annual Mercer University Lamar Memorial Lectures in 2013 was a most welcome and timely honor, offering me a perfect opportunity to experiment with my Chitimacha work through the three biographical essays published here. I am grateful to the late Eugenia Dorothy Blount Lamar, whose bequest has made it possible over many years for historians of the American South to present their scholarship in such a nurturing and accessible manner. And to Sarah Gardner, David Davis, Doug Thompson, and Tom Scott, I owe hearty thanks for the hospitality and inspiration that they shared with me over a few delightful early October days in Macon, Georgia. Through the Americanist Work-in-Progress Seminar, the Robert Penn Warren Center, and the Vanderbilt History Seminar, many colleagues at Vanderbilt University provided valuable feedback for portions of this book. And for a generous and helpful reading of the entire manuscript, special gratitude goes to Theda Perdue. Her personal friendship and professional leadership continue to brighten my path. This book also benefited plenty from copyediting by Helen Myers, whose careful influence as an editor was supplemented by her enthusiastic interest as an ethnomusicologist. Thanks also go

to Jon Davies, staff editor at the University of Georgia Press, for attentively facilitating the publication process.

Rhonda Seals Usner—my steadfast research partner, critical reader, and soul mate—has endured more of my discourses and detours into Chitimacha basketry than anyone could imagine, and for her love and support I owe way more than can be adequately expressed. The formative years of this project coincided with my parents' suffering and passing from terribly complicated health problems. A family is never prepared for such trials and losses, but my sister and brother demonstrated in their own marvelous ways what devotion, sacrifice, and trust really mean. I dedicate this book to both of them with deep love and gratitude.

Weaving Alliances with Other Women

"Entirely a Philanthropic Work"

≈ ≈ ≈ ≋ ≋ ≋

Mary McIlhenny Bradford,
Benevolent Merchant

Mary McIlhenny Bradford had recently returned to her home on Avery Island from her very first visit with Chitimacha Indian families in Charenton, Louisiana. "I saw and learned a great deal," she wrote to Christine Paul, "and one thing I learned was what a great deal of trouble it is to make one of these double weave baskets, & how much patience it takes too." As a consequence of this discovery, Bradford now promised Paul—one of the Chitimacha weavers from whom she had already been receiving baskets—that she would ask the dealer in New York City currently selling them to pay a higher price for each basket. A check for $8.20 was enclosed in Bradford's letter to cover the difference between prices already paid by her and prices hopefully forthcoming from the New York merchant. "If the man wont pay me," Mary said, "well then it will have to come out of *my* pocket." Mary then urged Christine to have all weavers "make them perfect." Whenever a basket's "every little line" is woven smoothly and tightly, the way ninety-year-old Clara Darden makes them, Bradford would award a cash prize to its maker. A perfect basket "sells for more," she declared. "Remember always I am trying to help you and all the other Indians and trying to sell your baskets for you," Mary Bradford implored, "but you must send them all to me, so I can send them to the people who order them from me."[1]

As one might discern from this July 4, 1902, letter sent by Mary

Bradford, Chitimacha Indian women were by then weaving their baskets for a market unlike any they had previously encountered. Their ancestors had been making river-cane baskets for household use and regional trade over many generations, expanding an indigenous network of exchange to include European and African participants. It was not uncommon well into the nineteenth century to see Chitimacha and other Louisiana Indian women peddling their baskets door-to-door or selling them in markets and stores. But toward that century's end, these forms of local commerce fell into decline. With handcrafted items giving way to store-bought housewares, fewer Chitimacha women learned how to weave traditional baskets, and aesthetic standards set by earlier generations became harder to sustain.[2] Rather suddenly, however, Chitimacha basket weaving began to recover in beauty and value because of a new interest taken by white women of privilege in things made by Indian women—much like what was happening among Indigenous communities elsewhere in the United States. Plenty of fruitful scholarship has been devoted to the production of Indian handicrafts for patrons, dealers, tourists, and ethnographers in the American West, but for the American South we still know too little about equally important relationships forged by American Indian craftswomen with prominent white women and other consumers.

The experience of Chitimacha Indians during the early twentieth century provides an opportunity to explore important interaction between American Indian artisans and patrons in a part of the South still inhabited by various Indian groups, adding to what Sarah H. Hill has already accomplished for the Cherokees in North Carolina.[3] Movement of select objects from the hands of their producers into those of consumers had consequences both inside Indian communities and across American society. As collectors sought an authentic "Indianness" in items like baskets, ceramics, and textiles, Indian families experienced an unprecedented imposition of commissioning, supervising, and negotiating pressures from outsiders. The efforts of Indian and non-Indian women to make basketry both economically profitable and culturally tradi-

tional—what we might call the crafting of a new market—comprised an intricate exchange of values as well as goods. In a rather sudden reanimation of Chitimacha basket weaving in the early twentieth century, we can see both the challenges and opportunities that patronage of the arts and crafts presented to Indian communities a century ago. Tracking communication among the women who made baskets, the women who promoted their production, and the dealers and ethnologists who purchased them also admits us into a wider discourse about culture and economy in early twentieth-century America.

Thanks in large part to Mary McIlhenny Bradford, a white woman living on Avery Island thirty miles west of their community, the Chitimacha Indians—confronting a dire moment in their history—were able to enter a brand new and most timely network of communication and commerce. Like many Indian communities scattered across the southeastern and northeastern United States at the end of the nineteenth century, the Chitimachas had been reduced to a tiny possession of land and now went unrecognized by the federal government. Chitimacha people had inhabited wetlands across the Atchafalaya Basin for centuries, farming domestic crops and harvesting wild foods along waterways between the Mississippi River and Bayou Teche. But by the 1880s only about fifty-five Chitimachas remained in the small town of Charenton on Bayou Teche, a narrow and sluggish stream lined with cypress and oak trees standing above tall palmettos. Half of this population still spoke the Chitimacha language, and all spoke Creole French, as observed by linguist-ethnologist Albert Gatschet during a winter visit. When not catching fish and game or tending to small cornfields, Chitimacha men worked seasonally for wages at sugar plantations and cypress timber camps. The women, "more industrious than the men" in Gatschet's opinion, manufactured "baskets and other utensils."[4]

The particular kind of basketry finely woven by Chitimacha women—from narrow splints of native cane (*Arundinaria gigantea*) intricately designed with naturally dyed colors of yellow, red, and

black—had already achieved some notability, at least across south Louisiana. A guidebook written for the 1885 Cotton Centennial Exposition in New Orleans, informing visitors about Indians within the state, proclaimed that the Chitimachas' baskets "are really objects of art." "North of Mexico there is no tribe in which such exquisite specimens of both workmanship and color can be found," the authors of this book opined. "So much sought for are these baskets that it is with difficulty that they can be obtained. $15 to $20 being asked for the larger. They will not make them without an order, and even then they have to be coaxed and cajoled." Among countless objects displayed at this world's fair were twenty-four Chitimacha baskets loaned by *New Orleans Times-Democrat* writer Charles E. Whitney and exhibited in Louisiana's Agricultural Division. "The first thing observable about them," as reported in Whitney's newspaper, "is the brilliancy and durability of their colors, which are produced by dyes or stains, the secret of the composition of which rests entirely with this tribe, and which no one can wrest from them."[5] Listing for *Harper's Magazine* readers the various groups of people encountered along Bayou Teche in the mid-1880s, Charles Dudley Warner simply referred to the Chitimachas as "basket-making Attakapas." Alcée Fortier, a professor of French language and literature at Tulane University, observed in 1890 that "the women make very pretty reed cane baskets, quite different in design from those which the Choctaws sell at the French market in New Orleans"—about an eight-hour train ride from Charenton. In Grace King's popular history of New Orleans (1895), a delightful drawing of Chitimacha baskets illustrated the opening page of her chapter on American Indians.[6]

Mary Avery McIlhenny, the woman most responsible for expanding interest in Chitimacha baskets far beyond Louisiana, was born on January 10, 1869, when her father Edmund McIlhenny was just starting the business of making Tabasco sauce on Avery Island. A New Orleans banker before marrying into the sugar-planter family of Judge Daniel Dudley Avery, McIlhenny was seeking ways to recover the family's fortune from the effects of the

Civil War. Along with her siblings and Avery cousins living on the island, Mary—nicknamed "Marigold"—received her formal education from tutors hired by the family. Her only sister was Sara, eight years older and the firstborn child of Edmund and Mary Eliza. "Sadie," as she was called, attended for a while the Catholic school of Mount Carmel in New Iberia—ten miles northeast of Avery Island. Mary and Sara, however, did not share in the opportunity that their brothers John, Edward, Rufus, and Paul took to attend academies and colleges in the Northeast.[7]

The home of Mary Avery McIlhenny was a forested island on Louisiana's Gulf Coast, three miles long and two and a half miles wide, one of several salt domes in the area that stand prominently above surrounding marshlands. Charles Dudley Warner visited Avery Island when Mary was an adolescent, calling its highest hill at 180 feet above sea level "a veritable mountain." Like everyone else, this journalist had to travel over a long straight road through the marshes and a short bridge crossing an alligator-filled bayou to reach it. "A portion of the island is devoted to a cane plantation and sugar-works," he wrote, "and on the lowlands and gentle slopes, besides thickets of palmetto, are gigantic live-oaks, moss-draped trees monstrous in girth, and towering into the sky with a vast spread of branches." Making this place truly extraordinary was a salt mine that had been famous since the Civil War, and also "here [was] grown and put up the Tobasco pepper."[8]

Mary Avery McIlhenny married Sidney Bradford in 1895, five years after her father died and her brother John assumed leadership of the Tabasco sauce company. The son of a prominent attorney, a Cambridge-educated entrepreneur, and an energetic member of the Crescent City's elite social and sports clubs, Bradford reinforced Avery Island's already strong family ties to New Orleans. This personal connection included the marriages of two Avery aunts, one to businessman Paul Leeds and the other to Tulane University president William Preston Johnston. Along with other Averys and McIlhennys, Mary Bradford enjoyed extended stays in New Orleans, especially during the Carnival season, but she spent

much of her life on Avery Island. Shortly after their marriage, Mary and Sidney received from her mother a new house built just for them on a hill located toward the island's west end.[9]

Mary Bradford sent a letter in June 1899 to Chitimacha Chief John Paul, who replied within only a few days. Yes, he wrote back, there were "some old indian women" still making baskets who could "make one like you ask for." The cost would be twenty dollars because it is "hard to make," he added. John Paul also answered an inquiry that Bradford made about the Chitimacha phrase for "Happy Hill," the name she wanted for her new home on Avery Island. He translated this into "Naie Weaby-ni-chatam." But, as thirty-year-old Mary wrote in her diary, she was "afraid it [was] too unpronounceable."[10] Christine Paul, a Chitimacha woman in her mid-twenties, wrote to Bradford three months later letting her know that "your Basket is finish." But her father-in-law, Chief Paul, had underestimated how long it would take to make. It took a week of their time just to collect enough cane along the shore of Grand Lake. Difficult to reach through dense forest, this body of water was fast becoming bordered by shell-filled levees erected on adjoining plantations. The scarcity of cane alone meant that a price of twenty dollars for such an elaborate basket was too little. Altogether six weeks of daily work went into this basket, Mrs. Paul reported. A white man had come by and offered thirty-five dollars, but Christine told him that it was already committed to a lady. So she begged "Mrs. Sydney" not to be offended by a request for twenty-five, also asking her to conceal from other people how much she paid. Two women actually made this basket—Miss Clara Darden, an elderly "old made" who wove baskets for a living, and Christine Paul herself, who assisted.[11]

No matter its size, form, and design, every Chitimacha basket resulted from the same series of laborious steps and dexterous skills. First of all, the wild river cane (*Arundinaria gigantica*)—named *pi'ya* in the Chitimacha language—had to be cut at just the right width and length from the banks of a bayou or lake. By the beginning of the twentieth century, as Christine Paul's report to Mary Bradford indicated, canebrakes that had once been ubiqui-

tously located and densely packed were drastically diminished by plantation and transportation projects, and basketmakers needed to travel longer distances to find suitable patches of the plant. After the canes were carried home and while still green and soft enough, weavers split and peeled them into very narrow splints ready for drying and dyeing. Splints to be colored black, yellow, or red went through additional steps of preparation. As Paul would later describe the dyeing process for Bradford, cane boiled in water with hulls of black walnut (*Juglans naira*) over an eight-day period became black. For splints of yellow and red coloring, a wild root known as swamp dock (*Rumex verticillatus*) and called *powaa'c* in Chitimacha was gathered from nearby wetlands. After leaving cane outside in the dew for eight nights, the weaver boiled some with *powaa'c* for a half-hour in order to achieve the yellow color and prepared the rest for processing into red. The latter were soaked in lime for an additional eight days and then boiled with the root for about fifteen minutes to reach a distinctive red color. With cane splints at last ready, the weaver could begin plaiting them into the shapes of mats, trays, bowls, and boxes—even needle and cigar cases—of various sizes. Surfaces on the sides, bottoms, and lids of baskets were deftly woven with dyed and undyed splints into one of at least sixteen beautiful patterns.[12]

When Mary Bradford's initial inquiry reached the Chitimachas, the tribe was already experimenting on its own with the aesthetic appeal of their rare baskets in a legal battle against dispossession. Nevertheless, reasons why Bradford began taking a passionate interest in this small Indian community near her family's estate on Avery Island warrant careful attention. Eventually joined by older sister Sara McIlhenny, Mary Bradford's ability to reach consumers, collectors, curators, and anthropologists opened a new and diverse market for Chitimacha baskets. For the Chitimacha people themselves, an alliance with the McIlhenny sisters raised hope that production of their distinctive cultural objects would boost appreciation for their status as an Indian nation. More and more Americans, as they learned, were associating the "authentic

Indian" with some kind of craftsmanship apparently facing extinction. Mary and Sara saw their own role strictly as saving a nearly extinct craft and helping a needy community, thus representing attitudes and initiatives taken by many upper-class white women in the early twentieth-century United States toward Indian people as well as other rural folk.[13]

Two maternal aunts of "Marigold" and "Sadie," Sarah Avery Leeds and Margaret Avery Johnston, had already broken a path for them. Both supported Acadian women who made a unique style of homespun cotton cloth by placing their fabrics in stores and homes around the country. In 1893 they accompanied five Acadian weavers to the Columbian Exposition in Chicago to demonstrate their methods and products at the Louisiana exhibit.[14] And they were undoubtedly responsible for bringing Chitimacha basketry to the attention of nieces Mary and Sara. In 1883 Leeds donated a nest of ten Chitimacha baskets to New York's American Museum of Natural History, and a decade later Johnston gave an even larger number of Louisiana Indian baskets to the Smithsonian.[15] In late 1898 Sarah Leeds received a letter from Ida M. Dyson of Kansas City asking for the "whereabouts of this old Indian woman who makes the best woven baskets in your part of this country." Dyson had acquired a number of Choctaw baskets during a visit to New Orleans but now sought items of "a different quality." Unable to pay a "fancy price," she was requesting an "honest price list" for different sizes of baskets. Leeds then relayed this inquiry to her niece Mary.[16]

On behalf of Chitimacha basketmakers over the ensuing years, Mary Bradford and Sara McIlhenny participated in an extensive network of upper-class white women who—out of philanthropy mixed with other purposes—connected Indian producers of crafts with influential consumers. Mary Bradford's numerous correspondents, for example, included curio-shop owners catering to tourists, department stores located in big cities, individual women seeking items for home decoration, anthropologists studying Indian cultures, and museum officials building public collections. Women such as the McIlhenny sisters brought a range of sensibilities and

motives to their patronage of Indian handicrafts: moral and aesthetic values, cultural and racial judgments, and personal and social interests. Class, gender, and national identities were wrapped up in what Philip Deloria has characterized as a shift from the interior otherness of noble savages to the exterior otherness of authentic folk. In this late nineteenth- and early twentieth-century transition, "industry" among American Indians was depicted as an antimodern livelihood, conveniently placating white anxiety over industrialization and urbanization. Partly a response to assimilation and impoverishment resulting from earlier U.S. Indian policies, white women's preservation of nearly extinct forms of production among Indian societies meshed with their advocacy of policy reform during a period that Tom Holm aptly calls "the great confusion in Indian affairs."[17] Buying and selling Indian handicrafts constituted, in the words of Molly Mullin, "respectable social benevolence," channeling women's consumer skill to public service. By the 1930s, after decades of trying to destroy Indian identity, the federal government would take action to protect and promote Indian arts and crafts. Contributing significantly toward this shift in policy was a rise in non-Indian taste for objects produced by Indian women, with white women playing a pivotal role. As a traditional practice that did not threaten the dominant society and even catered to its current desires and fads, Indian basketry was vigorously and widely encouraged at the start of the twentieth century.[18]

The opportunity offered by Mary Bradford, just beginning with that letter to Chief John Paul in the summer of 1899, profoundly affected the direction of Chitimacha life in a way still fondly remembered today by both the Chitimacha tribe and the McIlhenny family. But like comparable patronage relationships in other places and times, the intricate interaction of the McIlhenny sisters with their Chitimacha neighbors in St. Mary Parish, Louisiana, was riddled with incongruent purposes and incomplete perceptions. Understanding how the Chitimachas themselves responded to philanthropic, scientific, and aesthetic outreach is, of course, an essential part of this story. And as the start of their relationship with the McIlhennys foreshadowed, expressions and represen-

tations of Indian identity had to cross complicated cultural and economic lines during a pivotal era in the history of the American South and of Native America.

The beginnings of a complicated relationship with Mary Bradford can be detected in an early letter sent by Christine Paul, only a week after introducing herself to the white woman, and also signed by Clara Darden. After announcing that a basket was in the mail and enclosing the shipping receipt, Christine indicated, "we can put 5 baskets of the size you are speaking in one next." Since they "never made this kind of baskets in nests before," Darden and Paul could not determine the price until their work was done. Referring to the large basket previously made, they asked Mary to notify future buyers that it would cost no less than thirty-five dollars. "Chief Paul himself said that it can not be done for less." They then pleaded, "If you would be kind enough to send us a few dollars more we would be glad of it for we have been losing time and money at the price we made it, and it was only because it been agreed to make it at that price that we did make it." Invoking the authority of their community leader and emphasizing the extra difficulty raised by special requests would become a regular feature of Chitimacha correspondence with Mary Bradford. Conveying eagerness to satisfy such an influential white neighbor, for their own benefit of course, Darden and Paul expressed even their most assertive salesmanship in a tone of deferential gratitude. "We make these baskets in different shapes and patterns of design such as hearts, round baskets, cigar cases," Christine Paul reported in closing. "Should you honor us with any more orders then we would be very thankfull to you."[19]

Mary Bradford, fast becoming a special type of merchant, began to connect Chitimacha basket weavers, directly and indirectly, with some of the nation's most influential advocates of Indian arts and crafts. Neltje Blanchan De Graff, married to publisher Frank Nelson Doubleday and best known as a naturalist writer, wrote to Bradford in September 1900 that it "gladdened my heart" to learn from Mrs. E. John Ellis about "your interest in the native basketry of Louisiana." Ellis, by the way, had been informed about Mary's

new interest in a letter from Sarah Avery Leeds. "Some years ago," when visiting Grace King in New Orleans, Mrs. Doubleday had purchased at the Christian Women's Exchange several Chitimacha and Choctaw baskets "which have been a delight to the eye and the envy not only of friends but of ethnologists connected with our large museums." "The Indians are poor," Doubleday expounded. "They need remunerative work and the sympathetic personal contact of white ladies. Mrs. Ellis tells me that old squaws consider it necessary to file their teeth in order to split the cane. Therefore young women and girls are unwilling to practice basketry. But surely white people's tools could be found to substitute for filed teeth!" Doubleday ended her letter by saying: "I do not know of any sure practical missionary work we Americans can do than to uplift our Indians; and please do not think me a woman of one idea if I tell you that after fourteen years of work for them I am persuaded that there is no more promising way of helping them to all higher things than through fostering their worthy means of self-support, self-respect."[20]

The Christian Women's Exchange in New Orleans, where Doubleday had bought Louisiana Indian baskets, was already an important local link in a national network of "white ladies" who supported Indian arts and crafts. Established in 1881, this organization, in which Mary's aunts Sarah and Margaret actively participated, was committed to providing relief to impoverished women by encouraging them to "become artistic workers in all the great and grand affairs of human life, both practical and ornamental." By the end of the nineteenth century, the Exchange owned a building on the corner of South and Camp Streets. On the ground floor of this downtown location, the organization operated a store that sold bedspreads, crocheted handkerchiefs and bags, hooked rugs, and other handicrafts, produced mostly by women in the rural South.[21] The store inventory for 1892–94 included some eighty baskets of various origins, and the New Orleans Exchange was responsible for displaying and selling a large quantity of Louisiana Indian baskets at the Woman's Building of the Chicago World's Fair in 1893. Chitimacha and Choctaw basketry continued to be sold at

the Exchange store well into the twentieth century, and sometimes the store shipped them to distant buyers.[22] Comparable nonprofit stores existed in other major cities, including New York—where the General Federation of Women's Clubs ran a Woman's Exchange that in 1901 featured an exhibit of Indian baskets collected by Marion C. Pearsall of Washington, D.C.[23]

Three months after contacting Mary Bradford about the Chitimachas, Neltje Doubleday presented a lecture at the annual meeting of the Women's National Indian Association (WNIA) in Philadelphia. Devoted to philanthropy and policy reform since 1879, this organization (renamed the National Indian Association in 1902) started the Indian Industries League in 1893 to promote Indian arts and crafts for economic improvement. In "Two Ways to Help the Indians," Doubleday boldly articulated the sentiments that were then circulating among many upper-class women: "After two centuries of perhaps the most cruel mistakes the Anglo-Saxon has ever perpetrated on a subject people, the friends of the Indian today are unanimously agreed that what he chiefly needs to save him from still lower degeneracy are industries that will give him the means of self-support, self-respect."[24] The woman who had first brought Mary Bradford to Doubleday's attention—Mrs. E. John Ellis—headed the New Orleans chapter of the WNIA, which usually met at the Christian Women's Exchange and was very active in the national organization.[25] Daughter of Natchez planter Harvey Chamberlain and widow of Louisiana judge and legislator Ezekiel Ellis, Josephine Ellis served as southern vice-president of the WNIA for twenty-one years until her death in 1912. The Association's founder and national president Amelia Stone Quinton addressed the New Orleans group on March 15, 1902.[26]

Only a few days after WNIA president Quinton's visit to New Orleans, Ellis wrote to Mary Bradford acknowledging receipt of two "lovely" baskets priced at $3.55. She was "so sorry to hear that your Indians have been in trouble but rejoiced to hear that the girls are learning to do this lovely work and hope you will encourage them all you can. It means a good living for them in the future if they . . . will only cling to the original dyes." Ellis's own efforts to motivate

Choctaw women near her Covington home to do this were "so far without avail." Bradford had apparently sent a sketch of a basket style that she desired from the Choctaws, which "the Indians of years ago used to make." Ellis would try again to get them to make one, but was pessimistic in a way all too common among patrons of Indian crafts. "They are emphatically lazy," she wrote, "and the inducement of *money* seems to be no incentive to exertion on their part." Finally, Ellis mentioned Amelia Stone Quinton's speech on "the interesting Indian question" last Thursday. She wished that Bradford could have attended and now wondered if she would join the WNIA for a dollar-a-year dues and help recruit additional members. The next meeting of the New Orleans chapter would be held at the Christian Women's Exchange on April 2. "It is a *noble*, useful work."[27]

It turns out that Mary Bradford was far less engaged with the nationwide Indian reform movement than was her friend Josephine Ellis, but this makes her relationship with the Chitimacha community all the more instructive—allowing us to see the influence of a strictly local relationship between Indian and non-Indian women. Bradford busily corresponded from her home on Avery Island with men and women across the United States on a fervent mission to increase demand for Chitimacha basketry, but her interest in U.S. Indian policy never seemed to reach beyond the adversity and poverty facing this one neighboring tribe. By December 1901, Bradford was regularly ordering baskets with precise specifications for style, design, and price. She and Doubleday awarded cash prizes for the best work and separately found buyers around the country. A group of baskets received in November 1901 at her New York City home delighted Neltje Doubleday so much that she instantly praised their unique beauty and artistry in a letter to Bradford. "Sure of a very large sale for such work here in the East," she identified the baskets deserving prizes, although "it is difficult indeed to say which work is best when all is so finely done." Doubleday was now confident that "any orders I forward will be filled" because of Bradford having introduced her to Chief John Paul, who "deserves

some praise not only for encouraging the women to do this work" but also for discouraging use of artificial dyes that were "spoiling so much modern Indian work." She anticipated being able to sell at least twenty-five dollars worth of Chitimacha baskets every month. Thanking Bradford for her "hearty cooperation," Doubleday wrote, "If there were such friends of the Indian as you in every case, how the Indian industries would boom!" In a letter sent directly to Chief Paul, she reported showing the recently received baskets to Frank Covert, a major dealer located at 329 Fifth Avenue, who "would like $100.00 worth as soon as the women can make them." "The women and girls can earn plenty of money if they are willing to make all the Baskets I can sell for them," Nellie promised John—but not without pleading for them "to make handles on all heart shaped baskets. We cannot use them without handles."[28]

Christine Paul, who briefly attended a nearby Catholic school and was the most literate of the Chitimacha basketmakers, became the community's main correspondent with "Mrs. Sidney," the Indian women's form of address to Mary Bradford. When John Paul died in December 1902, Christine's husband, Ben, became chief. Letters between Mary Bradford and Christine Paul detail a pattern of exchange in which the patron requested particular numbers and types of baskets, acknowledged receipt and sent payment (sometimes in partial advance), and described her efforts to assist the basketmakers and their community. Christine Paul, in return, represented the basketmakers' wishes and needs. She mailed the baskets to Bradford's address at Avery Island (and once in a while in New Orleans), explained delays and problems in their schedule of production, and appealed for assistance with other issues confronting her people.

A ledger that Mary Bradford kept from mid-November 1901 to mid-December 1904 indicates that she bought and sold 1,932 baskets made by the Chitimachas during that period alone. The total amount paid to the Indian women for baskets received on twenty-six different dates was $1,851.80; the selling prices totaled $2,100.25. The difference of $116.29 left in Bradford's hands went into prize money, a school fund, and fees charged by attor-

neys for the tribe's land case. Through these responsibilities, Mary Bradford was able to utilize organizational and communication skills for which white women still found few outlets. Through their relationship with her, Chitimacha women found a new incentive to pass on weaving skills to another generation. At the end of 1901, fifteen women and girls at Charenton participated in the making of Chitimacha basketry. The adults were Clara Darden, Adele Darden, Rosalie Sennette, Constance Mora, Mary Navarro, Virginia Darden, Felicia Mora, Christine Paul, and Estelle Sanders. Younger weavers were Pauline Paul, Emily Mora, Mary Darden, Amelie Darden, Ella Mora, and Lucille Mora.[29]

One exchange of letters written early in the relationship between Mary Bradford and Christine Paul reveals rare evidence of the tension that did occur at times between Indian artisans and their white patrons. The year 1902 was especially hectic and stressful for the Chitimacha women and girls making baskets for distant buyers. Frank Covert had already relayed through Neltje Doubleday his large order for $100 worth of baskets.[30] In the meantime, Bradford was asking Paul for more mats, with "all of the different patterns on them," as well as an array of baskets with exact specifications in size, shape, and design. This sharp rise in demand occurred at a particularly tragic time for the community, following the shooting of Chief John Paul's daughter, brother, and son by three white men on Christmas Day.[31] By the summer of 1902, Hyde Exploring Expedition Indian Goods was eager to start selling Chitimacha baskets in its New York City store at 26 West Twenty-Third Street. Bradford was expressing favoritism toward certain weavers, while pressuring Christine Paul to lower prices charged for baskets. In a letter dated August 28, Paul regretted that Bradford considered prices too high but resented being blamed. "I just put what they ask for them. . . . If you find them to high I tell them to go little down." She also questioned a suggestion that Mary Bradford must have made to submit orders directly to each basketmaker, pointing out that "some they don't know how to read and write so . . . they put Baskets in my charge." Probably stung by the prospect of losing her intermediary role, Christine Paul wrote,

"I am sorry that you belive that I am chiting you but I not because I think you to good for us for me to do that with you." Bradford quickly responded to Paul's letter in a telling manner. "I did not expect it from you Christine that you should accuse me your friend of thinking . . . you cheated," she wrote. "It is not well Christine to repay kindness with ugly motives and ugly feelings." Bradford then poured out an earnest account of her generosity:

> Who was it, when you were all in such trouble at Christmas, advanced you the money to help you in your trouble! I knew nothing about you then but I trusted you & sent you the money you asked for & you proved worthy of your trust and paid me back all I advanced to you. Do you know what I am trying to do Christine, it is this—the Chitimachas Indians have for hundreds of years made the beautiful double weave baskets, but in the last 20 years they have had little or no sale for them so they did not make money. . . . I am trying, while old Clara Darden still lives, to get you all to learn from her to make the double weave baskets just as perfectly as she does. I write many letters to people about your baskets so as to sell them for you and I give the prizes my self when ever a basket is very well made. . . . I do this to try and make you all want to make the baskets as perfect as her baskets. When the baskets come I spend many days studying them. . . . [In] this last lot . . . many of the baskets were not . . . measured right so I thought that either they did not understand how to measure them & made the price according to the measures I had given you and that they had made.[32]

Disparate values and interests often added stress to the relationship between patrons and producers of American Indian crafts, especially when the exacting tastes of new consumers and collectors could seem detached from the pressing needs of most Indian communities.[33] Mary Bradford was driven perhaps most strongly by a desire for Chitimacha baskets to be included in the nation's most important exhibits and studies featuring American Indian baskets. In assuming this responsibility, she decided right away that baskets made by Clara Darden—the oldest woman in the community—were the authentic prototype for all other weavers to follow. Bradford obviously valued precision in both how

Chitimacha weavers created their baskets and how she represented their work. In her preoccupation with measuring the height and depth of baskets and in describing their shapes and colors, she was practicing what professional ethnologists also did with a large part of their time in distant laboratories and museums.

Mary Bradford's intercultural relationship with Chitimacha women was also complicated by the very different rhythm of life that she led as a woman of privilege in south Louisiana. She attended to her Indian work amid a busy social schedule, other intellectual and philanthropic activities, and undoubtedly her own personal challenges. After Bradford's husband Sidney failed at a risky partnership in the ice and coal business, he became manager of the McIlhenny Company's salt mine on Avery Island. The company itself was engaged in significant expansion beyond production of Tabasco sauce into the canning of seafood, fruits, and vegetables. Highs and lows in the larger family business naturally affected the time she had for her more modest promotion of Chitimacha baskets. During seasonal stays in New Orleans, occupied by the city's various cultural and social amusements, Mary Bradford did find time to volunteer her services at a kindergarten library and at other church and school institutions. Her early years of handling Chitimacha basketry were moreover marked by the high-profile weddings of her brothers Edward, Rufus, and John and by her family's legendary hosting of President Theodore Roosevelt's daughter, Alice, for the 1903 Carnival season. Between all these demands and distractions, Bradford fervently embraced the business of judging and pricing baskets, taking photographs of them for anthropological publications, and distributing information about their composition and design to dealers and curators.[34]

Determined to place Chitimacha baskets in prominent ethnological collections and thereby increase scientific and public appreciation for them, Mary Bradford quickly developed fruitful relationships with some of the nation's leading anthropologists. In April 1903 she received a letter from Otis T. Mason, the acting head curator of the National Museum's Department of Anthropology,

asking her to photograph her collection of Chitimacha baskets for his scholarly book on American Indian basketry, to be published by the Smithsonian Institution. "Mrs Doubleday," he wrote, "says that you have some of the very finest ones." Instructing Bradford how to arrange her baskets, he advised that she place them in front of a wall-hanging sheet "in such a manner as to show top bottom, sides, different parts in order to represent all the structure." "This is a scientific publication," Mason explained, "and we do not care for artistic or striking pose so much as to teach the lesson how Chetimacha baskets are made." Behind Otis Mason's request to Mary Bradford lay this anthropologist's belief, as he had recently written to Indian crafts merchant Grace Nicholson, "that women who desire to investigate the subject of basketry and textiles in a scientific manner, are especially fitted for the work since the makers of these textiles are women." Able to gain the confidence of Indian weavers and thereby elicit any stories connected to their designs, he told Nicholson, "you can also get the names of the plants, the names of the different kinds of baskets and their uses and thus really add to the stock of our knowledge." Whether Mason's theory was correct or not, Bradford certainly demonstrated skillfulness in acquiring such information. The photograph that she took for Mason appeared as plate 133 in *Aboriginal American Basketry* and represented, as he wrote in the text, "a fine collection of old Chetimachas." "They should be examined carefully," Mason urged readers, "since they were posed so as to exhibit the technic of the various parts."[35]

Scientific interest in American Indian baskets at the beginning of the twentieth century extended far beyond the emerging scholarly field of anthropology. Otis Mason's ponderous Smithsonian report swiftly reached a wider readership when later the same year it was commercially published by Doubleday, Page & Company—not surprisingly, considering Neltje Doubleday's personal connection to the publisher. A technically detailed and geographically thorough guide for collectors as well as scholars, this book also interested an array of social scientists and social workers whose agenda for progressive reform was informed by their thought about traditional

crafts. Seeking ways to smooth industrialization's impact on workmanship and to reify a spirit of communal creativity, John Dewey, Jane Addams, William I. Thomas, and Thorstein Veblen were among that era's most influential celebrators of "primitive" forms of workmanship as a source of inspiration for workers in the new industrial age.[36] And as a primitive industry closely associated with women, basketry held an integral place in this discourse among social theorists. In 1900 Otis Mason published *Woman's Share in Primitive Culture* to show that "the achievements of women have been in the past worthy of honour and imitation and have laid the foundation for arts of which we are now justly proud." Observing that "a great many" urban women were now working in textile and needlework occupations, he concluded that they "are still following the paths trodden long ago by dusky savages of their own sex." Mason then went on to assert that "aboriginal woman's basketry excites the admiration of all lovers of fine work" and "when women invented basketry . . . they made art possible."[37]

The early fieldwork of John Swanton, the Smithsonian anthropologist who would dominate southern Indian ethnology for a half century, owed plenty to Mary Bradford's personal devotion to Chitimacha basketry. After hosting Swanton on Avery Island during his first trip to Bayou Teche country in 1907, Bradford wrote to Christine Paul, "please ask your husband to *try* and *remember* and to tell him *all* he can ask old Clara too now she feels better please to try and remember some old stories." Telling Christine "what this gentleman is doing is an honor to your tribe or people," Mary promised to send her a copy "when it all comes out in a book."[38] Having joined the staff of the Bureau of American Ethnology in 1900, John Swanton went on to write plenty of books about American Indians in the South. Before retiring in 1944, he would produce twenty major works for BAE Bulletins and Annual Reports; fifteen of them were devoted to the study of southern Indians.[39] Local patrons or friends of Indian communities like Mary Bradford played an instrumental role in facilitating the fieldwork and scholarship of early twentieth-century ethnographers—especially in the South, where most Indians lacked recognition from the

U.S. government. Acquisition of cultural objects, not surprisingly, was a significant part of the relationship. Having arranged through Bradford the purchase of Chitimacha baskets for the Smithsonian, for example, Swanton displayed and explained them at the April 6, 1909, meeting of the Anthropological Society of Washington. And when his *Indian Tribes of the Lower Mississippi Valley* appeared in 1911, he proclaimed in the section on Chitimacha history that "the chief glory of the Chitimacha Indians from an industrial point of view is . . . its basketry," which "thanks to the interest and personal efforts of Mrs. Sidney Bradford, of Avery Island, has received a new impetus within recent years, and much which was on the point of being lost has been brought back to life." Information about Chitimacha basketry in Swanton's book, including a detailed explanation accompanying an illustration of nine baskets, "was in part obtained by the writer directly from the Indians, in part received from Mrs. Bradford, who had the advantage of a direct consultation with Clara Dardin, the oldest person in the tribe."[40] When Mark Raymond Harrington was sent by George G. Heye in 1908 to collect more American Indian objects for his expanding collection in New York City, this anthropologist added further testimony to Mary Bradford's influence by reporting that "the men do a little farming and work at various trades, while the women derive a considerable income from the manufacture of their famous baskets."[41]

Other women in the lower Mississippi Valley held a deep interest in American Indian basketry as well, but most of them were private collectors who devoted far less time to a particular Indian community than did Mary Bradford. Married to lumberman George Gardiner in Laurel, Mississippi, Catherine Marshall Gardiner became an aggressive collector of Native American basketry at the dawn of the twentieth century. Her passionate commitment to collecting old and new Indian baskets from across the country began, as she later recalled, while reading one day in a newspaper "that the work of the North American Indians would become scarce for the reason that the younger squaws with opportunity for education and with opportunity to purchase domestic utensils and ornaments would no longer make the necessary sac-

rifices in gathering materials nor use their time for the laborious weaving." Gardiner was able to travel to the West Coast once in a while but acquired most of her baskets through correspondence with commercial dealers and other collectors in Michigan, New Mexico, Colorado, California, British Columbia, and elsewhere. She also sold pieces from her collection to major museums. The legacy of Gardiner's "basket craze" in the South can be found today at the Lauren Rogers Museum of Art in Laurel, Mississippi, where Christine Paul's exquisite work appears prominently in one of the world's finest public collections of American Indian basketry. In August 1904 New Orleans businessman Thomas Sloo sent this set of six nested baskets to Catherine Gardiner, along with a note informing her that "they were made by the wife of the chief & in each you will find a slip of paper giving the Indian name & meaning of each design." This prominent New Orleanian more than likely acquired these baskets made by Christine Paul with direct assistance from his friend Mary Bradford, who, as he told Gardiner, "is trying to revive basket making by the Indians & takes great interest in their work."[42]

Amid the Indian basket craze sweeping across early twentieth-century America, Mary McIlhenny Bradford worked in a distinctive capacity. On the one hand, her marketing of Chitimacha baskets in no way resembled that of the commercial dealers in American Indian basketry with whom she communicated, like Frank Covert, Grace Nicholson, and J. William Benham. For these merchants, consumer demand for authentic and antique Indian crafts was their source of income.[43] On the other hand, Bradford lacked the deep wealth and wide interest possessed by other cultural patrons and social philanthropists who collected Indian baskets during those years. Among the most avid collectors of Indian baskets at the time was Margaret Olivia Sage, widow of financier Russell Sage, who purchased from Pasadena dealer Grace Nicholson in 1910 a selection worth $1,000. Two years later, coincidentally, Sage supported Edward McIlhenny's efforts to assemble coastal wetlands into a state wildlife refuge by purchasing nearly eighty thousand acres for conservation. It just so happens that Robert W. de Forest,

the attorney who negotiated the arrangement between McIlhenny and Sage, also, together with his wife, enthusiastically collected Indian basketry and pottery. (De Forest was by then vice-president of the Metropolitan Museum of Art.)[44]

Mary Bradford directed exclusively to the Chitimacha Indians a special blend of noblesse oblige and intellectual authority, a form of craft patronage that not surprisingly resembled that of her aunts Sarah Avery Leeds and Margaret Avery Johnston. As late Victorian women of some means and learning with a sense of civic responsibility, they and their nieces "Marigold" and "Sadie" focused on cultural characteristics and material needs of local people they considered quaint or colorful. Johnston's prominent role in founding and supporting the Louisiana Association of the American Folk-Lore Society—in addition to her and her sister's interest in Acadian homespun and Chitimacha basketry—and then Sara McIlhenny's later publication of "Negro Stories" in *Atlantic Monthly* all point to what historians of folklore studies have long observed. During the early years of this field's development, women found a rare opportunity through the publication of folk narratives and the collection of folk materials to participate professionally in a new sphere of intellectual and intercultural exchange.[45] It was one of those areas in late nineteenth- and early twentieth-century society where, as Sara M. Evans noted some time ago, women without college educations and careers managed to engage in self-development and benevolent activities. Mary's deployment of entrepreneurial and communication skills on behalf of the Chitimachas also exemplified what Jackson Lears more recently argued about upper-class women's selective remaking of themselves during this period.[46]

Paralleling the more familiar ways in which well-to-do men pursued social responsibility and character building during the Progressive Era, women in their families played their own influential role by supporting a variety of cultural institutions and artistic endeavors. Protecting the Chitimacha craft of basketmaking against extinction marked Mary McIlhenny Bradford's pursuit of this moral aesthetic. And while elite white women were applying their femininity to the preservation of delicate crafts—helping

Indian families and communities survive—elite white men were testing their masculinity through adventures in the wilderness—imagining themselves replacing extinct Indians. It just so happens that Bradford's brother John McIlhenny accompanied Theodore Roosevelt on two famous bear hunts during his presidency, joining him in Mississippi in 1902 and hosting him in Louisiana in 1907. John McIlhenny had served in Roosevelt's Rough Riders in 1898, and in 1906 President Roosevelt appointed McIlhenny, by then a state senator, to the U.S. Civil Service Commission.[47]

Although Mary Bradford's promotion of Chitimacha basketry undoubtedly reflected an outsider's ethnographic and romantic gaze upon Indigenous culture, it was mostly driven by her concern for a vulnerable community's overall welfare.[48] When Bradford learned about government plans to feature American Indian arts and crafts at the 1904 Louisiana Purchase Exposition in St. Louis, she included in her appeal for a Chitimacha presence at this world's fair a strong effort to enroll Chitimacha children in an Indian industrial school. As Bradford explained to Samuel McCowan, superintendent of the Chilocco Indian School in Oklahoma also serving as organizer of the Indian exhibit, she "found them a most intelligent people, though absolutely without education. Hence the necessity of my doing *this* work for them, which is entirely a philanthropic work on my part."[49] And this push for the education of Chitimacha children was only part of Mary and her sister Sara's larger campaign on behalf of the Indian people at Charenton.

By the 1920s, after their alliance with the Chitimachas resulted in federal protection of their tribal land, Mary Bradford's and Sara McIlhenny's involvement with the community waned in frequency and intensity. Once in a while, they would request from Christine Paul a shipment of baskets or send a small gift of money. And when Smithsonian anthropologist Henry Collins traveled to south Louisiana in 1926, they assisted in his visit to Charenton.[50] This decline in Bradford's and McIlhenny's advocacy most likely reflected the phase in their own life histories as well as the fall in public demand for American Indian crafts. After her husband Sidney died

in 1931, Mary Bradford concentrated on placing a headstone on the grave of Clara Darden, offering a selection of her own Darden-made baskets to several different museums in order to raise money for this purpose. She had promised Darden that this would be done "to commemorate the work she did for the girls of her tribe by teaching them to make the beautiful baskets" but could not afford it at the time of Darden's death in 1910. John Swanton and Clark Wissler reported that their institutions, the Smithsonian Museum and the American Museum of Natural History respectively, could not purchase the nest of eleven double-weave baskets with covers, but Donald Scott of Harvard's Peabody Museum was able to offer fifty dollars for the set. Regretting that a shortage of funds did not permit a higher amount (she originally asked for $100), Scott wrote to Bradford that "we shall regard this accession, due to the care which you have expended . . . in securing information regarding their manufacture, as a valuable addition to our collection."[51]

In one of her last extant letters to Christine Paul, Mary Bradford requested samples of the root plant from which the Chitimachas made red dye for their baskets—for forwarding to the Peabody Museum—as well as information about Clara Darden's birth and death years, for ordering the cemetery headstone.[52] With the money received for the baskets sold to Harvard's Peabody Museum, Bradford could finally purchase an engraved headstone and arrange a ceremony to place it at the grave in 1934. "The whole tribe went with me to the cemetery," as she described the event to Donald Scott. "I placed the first trowel full of cement under the stone, then each of the Indians did the same." The inscription on the stone reads: "Clara Darden 1813–1910 Taught Chetimacha Indian Basketry to Girls of Her Tribe Erected by Mrs. Sidney Bradford Mrs. F. N. Doubleday." Neltje Doubleday had sent ten dollars to Bradford sometime before her untimely death in 1918, and at an indeterminable point during the ensuing years Bradford composed a story about Clara Darden and Christine Paul. She had hoped to circulate "A Little Story of a Basket" as a means of soliciting contributions toward a headstone, but the plan was apparently never pursued (see appendix 1). At the cemetery in 1934

Mary did pencil under her own name on the stone "Ca mu-mê' stin," a Chitimacha phrase meaning "white flower," which is what Clara had called her long ago. When John Swanton received from Bradford a photograph of Darden's headstone, he agreed to place it with the Smithsonian's Chitimacha display and wrote, "She was certainly a remarkable old woman and, under your encouragement, has performed an equally remarkable and unique service to her people."[53] Undoubtedly gratified by this anthropologist's recognition, Mary Bradford must have deeply cherished her partnership with Clara Darden until her own death in 1954.

In the formative years of Mary McIlhenny Bradford's patronage of Chitimacha baskets, we see up close how the production and circulation of certain things—bought and sold to preserve a traditional craft—connected American Indian communities to much broader changes in American society. In regard to materials collected by Meriwether Lewis and William Clark a century before Chitimacha baskets became collectors' items, Scott Stevens has written, "A true engagement with these objects now requires us to integrate their contextual history as both Native object and collected artifact. This means discovering not only what the objects may have originally meant (and still may mean) to the indigenous peoples who created them but also that we must attend to the artifacts' trajectory through Euro-American culture."[54] While much of the literature on Indian arts and crafts has focused on a single participating group—producers, traders, patrons, or collectors—there is significant value in crossing cultural, class, and gender lines to study the interactions between all of these groups. A complex pattern of aspiring connections and frustrating discontinuities went into the development of Chitimacha basket weavers' relationship with Mary Bradford and her sister Sara McIlhenny.[55]

Early in the twentieth century, beautiful cane basketry produced by a small number of women in a southern Indian community moved across a vast space for purchase and display at many different locations—homes, stores, expositions, museums, and publications. With plenty of help from neighbor Mary Bradford, baskets that Chitimacha women and girls wove along the banks of Bayou

Teche were transported far from Louisiana to reach shelves in city stores and homes as well as glass cases in ethnographic exhibits. They also became topics for philosophical discourses on art, work, and industry. Circulation of these fascinating objects through a visual economy of scientific and social networks generated significant overlap among disparate activities—anthropology, folklore, philanthropy, curio commerce, the arts and crafts movement, and government policy, to name the most obvious. The kind of philanthropic enterprise managed by Bradford from her Avery Island home received validation from the rising field of anthropology, which in turn became more popular through the spread of exhibits, collections, and markets. The commercial marketplace of Indian handicrafts, meanwhile, substantially expanded opportunity for craftswomen such as the Chitimacha basket weavers as well as for craft patrons such as the McIlhenny sisters. The Chitimachas' ongoing struggle to preserve their remaining territory—the focus of the next chapter—also benefited from the new interest in Indian baskets, giving them at least some access to influential public attention. Following a century of dispossession and still facing indifference from the federal government, Chitimacha women found in both Mary Bradford and Sara McIlhenny much needed allies just when forces around their community grew more dangerous.

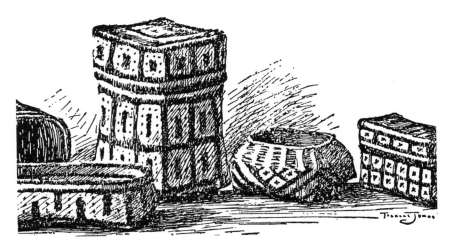

Detail of Frances Jones's drawing in Grace King's *New Orleans: The Place and the People* (New York: Macmillan & Co., 1895), page 75.

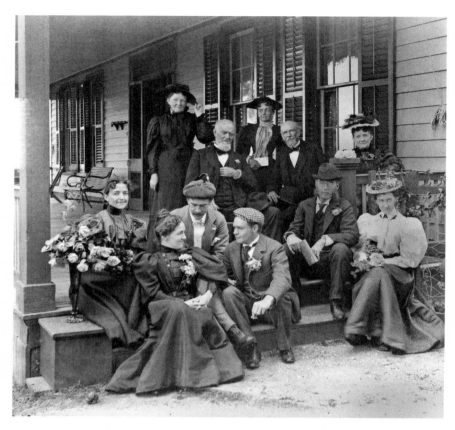

Members of the McIlhenny family and larger Avery family to which they belonged, Avery Island, Louisiana, circa 1890. Mary Avery McIlhenny Bradford is seated in the front row at far right; Sara Avery McIlhenny is seated in the front row at far left. Their father, the inventor of Tabasco sauce, is the man seated in the back row at center with cane and his hand reaching under his lapel. Courtesy McIlhenny Company and Avery Island, Inc., Archives.

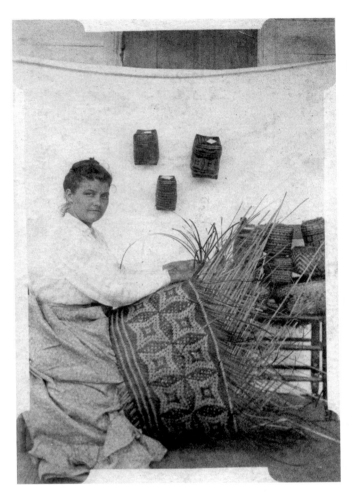

Christine Paul, circa 1903. Courtesy McIlhenny Company and
Avery Island, Inc., Archives.

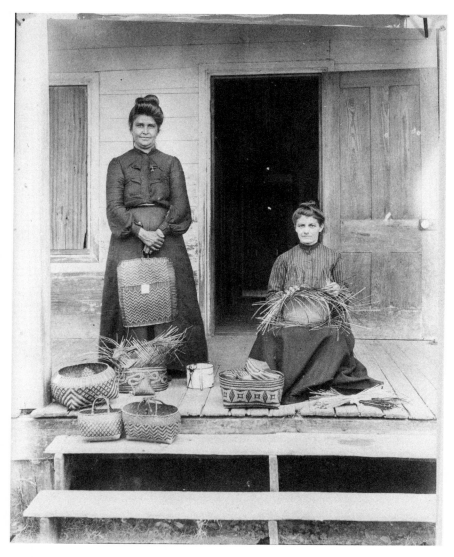

Delphine Stouff (left) and Christine Paul (right). Photograph by Mark R. Harrington, Charenton, Louisiana, 1908. Courtesy of National Museum of the American Indian, Smithsonian Institution (2838).

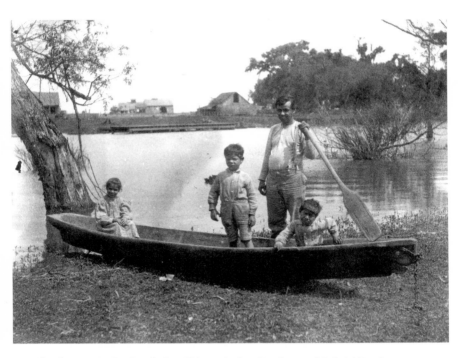

Chief Benjamin Paul with Jane Vilcan, Arthur Darden, and Gabriel Darden. Photograph by Mark R. Harrington, Charenton, Louisiana, 1908. Courtesy of National Museum of the American Indian, Smithsonian Institution (2847).

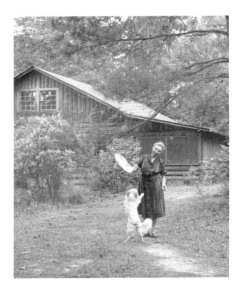

Caroline Dormon at Briarwood. Courtesy of Caroline Dormon Collection, Cammie G. Henry Research Center, Watson Memorial Library, Northwestern State University of Louisiana (1557-055). .

The Last of the
CANE BASKET MAKERS

By CAROLINE DORMON

FROM the bridge at the village of Charenton, one looks up Bayou Teche to a sweeping curve. Old, old live oaks peer out from beneath their shaggy locks of moss, as if to say: "What know you of men and things? Here today and gone tomorrow! We were here when life moved softly by in pirogues on this bayou; now it roars and rushes past on a hard white highway."

When the first French settlers came to this part of Louisiana, they found it inhabited by a tribe of peaceful Indians, the Chitimacha—or Cetimacha, as the French called them. How long had they been there? Ask those who are left today. "Always," they answer simply. Theirs was once a great nation, but now only a tiny remnant survives. No need to ask why they have disappeared. Like most of our primitive peoples, they could not withstand the rude shock of contact with our civilization. This part of Bayou Teche is still known as Indian Bend, and on these curving banks there live the few that are left of this ancient tribe.

As they had fixed habitations, the Chitimacha gave much time to cultivating the soil and developing the domestic arts. The women made everything that was needed in their daily life. From Indian hemp, a common weed, and the inside bark of mulberry, they wove a strong cloth. From these same materials they made ropes and pack-carriers. But in the weaving of baskets, they displayed the greatest skill. Their basketry reached such a degree of development that it might well be classed among the higher arts. Most remarkable of all, they still retain this art.

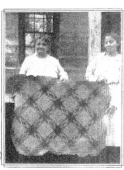

Finely woven cane mats like the above were used on couches, and for floor and wall coverings in ancient times.

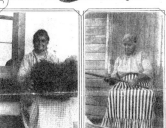

Two examples of double-seated baskets. The pattern on the larger is "alligator entrails." The smaller basket is decorated with "blackbird's eyes"

The oldest of the living basket makers and granddaughter of a chief

Detail of Caroline Dormon's "The Last of the Cane Basket Makers," *Holland's, the Magazine of the South* (October 1931), page 13.

"We Have No Justice Here"

𝕃 𝕃 𝕃 𝕃 𝕃 𝕃

Christine Navarro Paul,
Chitimacha Basketmaker

Reporting to Mary Bradford some current news from her community, Christine Paul mentioned a box of baskets recently shipped to Avery Island as well as another round of sickness afflicting her family. The bulk of this March 1905 letter, however, was devoted to the latest legal judgment against the Chitimacha Indians' remaining land along Bayou Teche. Wondering where to turn next for help, Paul bemoaned, "We have no justice here!" With absolutely no hope of local officials intervening on their behalf, she asked Bradford to "please have the kindness to do it for us." Whatever the cost, the Chitimachas would "fix with you any way you want" because as Christine already demonstrated to her white friend and patron, "I allway try retune you what I get." A relationship of trust woven through the basket trade indeed seemed like the best avenue for reaching outside allies and authorities. Although Christine Paul's main purpose was to solicit help from Mary Bradford, even enclosing with this message a copy of the state court's adverse decision, she made sure to mention that with everyone's health now improving, "we all stard working on our Basketry."[1]

We now know plenty about what happened to the meaning and purpose of things, such as those baskets promised by Christine Paul, once they left the hands of their producer and entered networks of science and commerce. From the perspective of Anglo-American participants, this movement of things added aesthetic,

scientific, monetary, and even political value to them—as the everyday and ceremonial objects of "other" people ended up in private collections inside their homes, in display cases at museums and expositions, in photographs and texts of scientific publications, and in debates and reports of reform organizations. But when it comes to what this movement of things meant and did for their Indian producers, we know far less. Could the circulation of Indian baskets among distant consumers and collectors, which undoubtedly altered their long-cherished customary value, also have returned some value to basketmakers in places like Charenton, Louisiana? Additional income at a time of great need was certainly an attraction worth considering. But might the intensified commodification driven by the arts and crafts market also have helped Indigenous communities retain access to precious land and water or even resist threats of assimilationism and racism?

Fortunately, more and more scholars who study the commercialization of Native American cultural objects are shifting their emphasis away from the damaging role of external forces—whether it be capitalist commodification, condescending primitivism, or colonial domination—and toward the constructive role that the Indian creators of arts and crafts tried to play in the expansion of market opportunities. Yes, the dominant society's embrace of Indigenous people's customs and traditions catered primarily to its own cultural desires and tastes, especially when those customs and traditions did not threaten dominant interests. But putting the circulation of Indian goods to work out of self-interest was not the exclusive practice of privileged white buyers and collectors. At a time when Indian communities confronted some of their most confining choices, new attention to the production of handiwork achieved a desirable combination of economic adaptation and cultural survival. Evidence demonstrates that participation in the arts and crafts market involved deliberate political goals and strategies. Whether rebuilding communities in the aftermath of war and displacement or seeking protection of land and resources, robust responses to elite white consumption of Indian material culture could make a difference.[2]

Christine Navarro was born on December 28, 1874, five years after Mary McIlhenny's birth, in a place both close to and far from Avery Island. Less remote from transportation routes and population centers than that sprawling island isolated by coastal marshes and inlets, Charenton stood thirty miles eastward along the oak- and cypress-lined banks of Bayou Teche, surrounded by busy plantations, refineries, and sawmills. By the time Christine Navarro's parents had been born—Joseph Auguste Navarro in 1848 and Augustine Marguerite Pladner in 1855—communities of Chitimacha people once spread across the Atchafalaya basin were reduced to a small group centered at Indian Bend on Bayou Teche. They practiced Roman Catholicism like their Cajun neighbors, and French became their primary language. Christine's mother died when Christine was only about seven years of age, and her father passed away only two years later. Probably living with her stepmother Marie Cecelia Navarro for a while, Christine also attended a nearby school run by the Sisters of St. Joseph. There she became literate enough in English to communicate with outsiders such as Mary Bradford. And as with other Chitimacha girls and young women, she learned how to weave basketry for local sales as well as how to harvest garden crops and wild plants. Christine Navarro married Benjamin Paul, who like most Chitimacha men worked seasonally at sugarcane plantations and cypress logging camps while also catching supplies of fish, shellfish, and game.[3]

Several months before Christine Paul reached her twentieth birthday, Congressman William L. Wilson of West Virginia, chairman of the House Ways and Means Committee, was touring Bayou Teche on a steamboat, with Congressman Andrew Price of Louisiana and local officials and planters also aboard. Amid stops at sugar plantations and refineries, the Wilson party visited, as a *New Orleans Daily Picayune* reporter put it, "the reservation of the Chitamatche Indians." The account of this stop went as follows:

> About 100 of these Indians are left. Hardly any of them speak their native tongue, but have a patois of French instead. They are very simple in their habits, but are peaceful and law-abiding. All of them live in

houses and cultivate gardens and small patches of ground. The women make baskets and do most of the work in the field, while the men spend their time riding Creole ponies and angling for catfish in the bayou. There are very few pure-blood Indians in this remnant. They have fused with the Spanish and French Creoles of certain classes. The baskets these primitive people make by their hands are novelties which bring a good price. At the world's fair many of them were placed on exhibition and were sold at a rapid rate. It was stated that only two of the women left in the reservation know the art of coloring the cane and making the baskets. The baskets are woven and the cane died in two colors by a secret process known only to the old squaws. The work is done artistically and pretty figures are formed. The baskets are made into all shapes and sizes. Mr. Price bought a number of the prettiest ones on hand. When the small boat was sent ashore to bring the old Indian woman and her daughter, who was a pretty maiden with a soft copper complexion, aboard with the baskets, Mr. Wilson walked to the edge of the boat and taking the girl by the hand, helped her on deck. The men aboard cheered the gallant congressman. However, Captain Taylor Cade [Wilson's New Iberia host] was not to be outdone, so he politely assisted the old lady in the same manner. The poor creatures seemed to appreciate the courtesy for they were perfectly silent for some time. The dicker for the baskets was very amusing. High prices were asked for each one, for the old woman was shrewd enough to know a good thing when she saw it. The bargains were made in a sort of jargon, several gentlemen aboard offering their services as interpreters on account of their long acquaintance and knowledge of the habits and customs of the Chitamatches.[4]

Although not mentioned in the newspaper, Congressman Price had earlier that year relayed to Secretary of Interior Hoke Smith a letter from Paul Nelson, then chief of the Chitimacha people, asking if St. Mary Parish of Louisiana had any right to tax their land. Commissioner of Indian Affairs Daniel Browning reported back to Smith that the Chitimachas did indeed have certified title to 1,093 acres, but he saw "no reason why their land should be exempt from taxation" and considered it "a matter over which the

Federal Government has no jurisdiction and must be definitely determined by the laws of the State and the decisions of the Courts of the State thereunder."[5] This explicit denial of federal responsibility, however, did not deter the Chitimachas from trying to retrieve land unlawfully purchased from tribal members after the U.S. Supreme Court had confirmed their title in 1852. The Office of Indian Affairs' failure to protect them from alienation of their land was a problem shared with many Indigenous communities in the eastern United States over the nineteenth century. Certain Indian groups in Louisiana, we now know, were entitled to federal protection on several grounds. In the Louisiana Purchase treaty with France, the United States had obligated itself to recognize Indian land rights that were protected under colonial law still in effect at the time. More generally, the federal government's preemptive right to purchase Indian land should also have been in effect—as secured under the Indian Trade and Intercourse Act of 1790, extended to the new territories of Orleans and Louisiana in 1804, and reinforced by the Supreme Court case of *Johnson v. McIntosh* in 1823.[6]

Nearly three years after Chief Nelson had addressed his letter to Secretary Smith, the Chitimachas brought a case to the U.S. Circuit Court in New Orleans charging several residents of St. Mary Parish for "tortious possession" of lands still claimed by the tribe. The defendants, in response, stated that the Chitimachas had been citizens of Louisiana for many years and further asserted that "there is not and never has been any nation known to and recognized by the United States as the Tchetimacha Indians with right to sue and plead as such in the courts of the United States." At first Judge Charles Parlange concurred with this opinion, dismissing the suit because it lacked federal questions, but an amended plea was submitted in early 1898 with prominent attorney Albert Voorhies serving as the Chitimachas' counsel.[7] While waiting for this trial to proceed, George Demarest of Franklin, Louisiana—an apparent liaison between tribe and court—reported to John Paul, now chief of the tribe, that he had delivered "to our Friend" some baskets, made by the chief's daughter, and that "he was very much please with them."[8]

In this legal battle over land rights, as hinted by the delivery of baskets to a "friend," the Chitimachas were putting the aesthetic appeal of their rare basketry to strategic use, explaining how a picture of Christine Paul appeared in a New Orleans newspaper. While the community anxiously awaited an opinion from the U.S. Circuit Court, the *Daily Picayune* ran a story in June 1899 informing readers about these Bayou Teche Indians and their land claims. "They hold that the sales were not valid," the reporter wrote, "because no allotments were made, and, moreover, the lands in question belonged to the nation and not to individuals." John Paul was quoted as saying, "We hold that the United States government should protect us in our grants. Our forefathers had no right to alienate the land. It is time that we should be permitted to enjoy the benefit of our inheritance." Sketched from photographs sent by the Chitimacha chief, likenesses of his daughter Pauline, daughter-in-law Christine, Manuel Vulcin, and Clara Darden were included in the article. It ended by reporting that "baskets made by the Chetimaches are very pretty, ranging in size from large baskets for ordinary domestic use, to small fancy ones, to be used in the sewing-room, or to ornament the bric a brac table." The author had apparently been shown an open basket woven by Miss Pauline Paul and a trunk basket and cigar-case basket made by Mrs. Christine Paul.[9] Eight months after the appearance of this article, Demarest wrote to Chief John Paul requesting that "the Girls" make more baskets, including one for the reporter "as he says he will write something good in the Paper for the Nation." Writing upside down on the top margin of this same letter, Demarest added, "John tell your Daughter to make me 2 Baskets and send them to me. I want to have them with me to show the court."[10]

By the beginning of the twentieth century, the Chitimacha Indians' possession of their remaining land had become extremely precarious; they lacked legal protection from the U.S. government and suffered a surge of racial hostility from white neighbors. Under these circumstances, the relationship forged by Christine Paul and other Chitimacha women on Bayou Teche with Mary Bradford and Sara McIlhenny, sisters living on nearby Avery Island, became cru-

cial in this community's pursuit of federal recognition. The production and sale of exquisite baskets gave Chitimacha Indians special access to desperately needed political resources. Through a network of communication with distant patrons of Indian arts and crafts—largely mediated by the McIlhenny sisters—the Chitimachas were able to reach allies and officials at a dangerous moment for the group's survival. Selling distinctive cultural objects to consumers obsessed with authentic Indian craftsmanship facing extinction, they hoped, might boost appreciation for their status as an Indian nation. The historical evidence reveals that the activism and perseverance of tribal members, as expressed through production and distribution of material culture, influenced the decision to extend federal trust status to the Chitimacha Tribe of Louisiana in 1916.[11]

The Chitimachas' petition for a new trial against unlawful occupants of their land, which had been lingering in federal court for months, was finally denied in April 1900. In Judge Parlange's opinion, the Supreme Court decision of 1852 had acknowledged "the right of the tribe to the full ownership of the lands" and therefore "the tribe had the right and power to sell them."[12] Only a few months earlier, Commissioner of Indian Affairs William A. Jones had reported to Secretary of Interior Ethan Hitchcock that his office could not assume jurisdiction over the Chitimachas because it lacked "complete and perfect knowledge" of the status of Indian lands in Louisiana. He nonetheless acknowledged that their thousand acres were owned in common, as established in the Supreme Court a half-century ago.[13] The Indian Office was inconsistent and arbitrary when it came to its relationship with eastern Indian communities during the early twentieth century. Racialized judgment of a group's qualification for federal recognition could influence whether to provide support, but in some cases it was simply a matter of conserving administrative resources and minimizing jurisdictional responsibilities. Even when local citizens sought federal interest in a community that they considered Indian, there was no guarantee of a positive response. The experience of southern

Indians, in particular, illustrates how inconsistent and tentative the shaping of racial inequality could be.[14]

Following Judge Parlange's decision in *Chetimachas Indians v. Delhaye et al.*, things deteriorated rapidly for the Chitimachas—with deeply painful effect on the family of Christine Paul. On Christmas Eve of 1901, Gabriel Mora and a few other young men from the community got into a drunken fight at Charenton. Jules Darden brought Mora home and returned to town for Christmas shopping. When Deputy Sheriff Alfred Pecot confronted him over injuries suffered by an African American, Darden denied being involved in the fight and resisted Pecot's attempt to hold him. A crowd then began beating Darden to the ground, but Delphine Stouff managed to drag him away. Stouff felt that Pecot would have shot her had not someone in the crowd dissuaded him. The next morning Pecot went to the home of Chief John Paul—well armed with his brother Charles Pecot and Ernest Delhaye as backup—and called for Oliver Paul, the chief's young son, to come out. When John Paul, his brother William Paul, and his older son Benjamin Paul walked out to the front gate, Pecot told them that he intended to arrest the boy, apparently without a warrant. Oliver came out of the house saying that he took no part in the fight, but the deputy sheriff's approach with handcuffs caused him to run back into the house. Then, according to an account later told by Chitimacha witnesses, all three white men fired their guns and instantly killed Oliver. The boy's uncle shouted, "This can't be done!" and attacked Charles Pecot with a whittling knife. He was "shot dead in his tracks." The posse knocked John Paul to the ground with their guns, as he cried, "You have killed my boy!" When his daughter Virginia Darden, eight months pregnant, tried to stop them from further beating John Paul, "they shot her in the head." Hearing his wife scream, Jules Darden—who was bedridden from wounds suffered the night before—began firing his shotgun through the cabin window. The posse then retreated. Later that day or perhaps the following day, John Paul, Benjamin Paul, and a couple of other Chitimacha men were arrested by the St. Mary Parish sheriff. They spent time in jail under charges of resisting a law officer but were

later released.[15] Virginia Darden survived but died from illness a year later.

An account of these tragic murders published in the *St. Mary Banner*, a newspaper in nearby Franklin, Louisiana, could not have been more discordant from that recorded years later by Chitimacha relatives of the victims. The headline of this December 28 story read in bold letters, "An Indian Uprising," which of course invoked for its readers the popular reportage of western Indian events. The Indians attacking the African American man in Charenton were reportedly "on a spree," and the deputy sheriff's pursuit of Oliver Paul on Christmas morning was described this way: "The moment the arrest was made there was a sudden uprising of the red skins, several more coming out of the building and joining those already on the scene. The prisoner made a desperate resistance and was killed. Bill Paul made a murderous assault with a knife on deputy sheriff Chas. Pecot and he was also killed. At that moment a woman appeared on the scene and received a load of buckshots in the head. The chief was wounded but made his escape." The rest of this article described in detail the injuries sustained by posse members and the medical attention they were receiving at Hotel Dieu in New Orleans. The white men were praised for showing "much pluck" because they overcame the disadvantage of being outnumbered and "captured the ring leaders of this trouble."[16]

A much longer article, headlined "Battle with Indians Right in Louisiana," had already appeared in the *New Orleans Daily Picayune* on December 26, as it reported the arrival by train of the wounded Pecot brothers in the company of their cousin Dr. L. F. Pecot and an attorney named J. Sully Martel. The sensationalized information and tone of this account resembled the Franklin newspaper's report. "That the men should be wounded in a desperate battle with Indians and in the state of Louisiana at this late day," the reporter exclaimed, "almost passes belief." The Crescent City newspaper, however, did offer an explanation of tension—derived from an interview with Martel—that might have contributed to this violent episode: the Chitimachas "appear to have harbored ill feeling toward the whites of St. Mary Parish ever since the suit which they

had instituted for the recovery of lands had been decided adversely to them." A section of the same article subtitled "The Chetimaches, Something about the Tribe Involved in the St. Mary Trouble"—the sort of historical account of Louisiana Indians seldom appearing in local newspapers—ended by saying that "their defeat in the courts was sullenly and resentfully accepted by the Chetimaches, and ever since they have showed their hostility toward the white man. The serious affair last Tuesday was but the climax of the long cherished discontent of the Indians."[17]

As if the bloody nightmare of Christmas Day 1901 and the hostile way it appeared in newspapers were not enough, the Chitimachas soon found themselves being sued by a group led by none other than George Demarest, claiming rights to nearly half of the tribe's remaining five hundred or so acres. Thirty-eight plaintiffs petitioned the Sixteenth Judicial District Court of Louisiana as "owners in common with the defendants" of the lands whose patent to the Chitimacha tribe had been confirmed by the United States back in the 1850s. They asserted that "under existing laws all rights of the grantees of said patent, have become vested in your petitioners and the said defendants individually," a fact "particularly shown by the judicial admission of the defendants . . . made in the suit of the Chetemachas Indians against H. Delhaye et al." "No longer willing to remain in indivision with defendants as co-owners of the said property or to hold it in common with them," they were now seeking a judgment against the defendants that would set in motion a partition of the property and a division of proceeds from its sale among plaintiffs and defendants. One of two attorneys for these petitioners was J. Sully Martel, the same lawyer who had accompanied those injured St. Mary Parish deputy sheriffs to New Orleans after the Christmas Day murders of 1901 and provided information about the event to a *Daily Picayune* reporter.

Christine Paul, her husband, Ben, and the other defendants in this case answered by denying that the plaintiffs were owners "in common with Defendants" or that they ever possessed any por-

tion of the property. Moreover, they rejected the notion that the plaintiffs' entitlement to land was ever voluntarily and legally admitted in the *Delhaye* case or on any other occasion. The defendants asserted, on the contrary, that "a great and a grievous fraud was committed upon them by the said George A. Demarest, and Paul Nelson, who conspired together to cheat and defraud them of their just rights." In their defense, these Chitimachas claimed that Demarest had pressured them into bringing their suit into federal court with the intention of getting himself elected chief and attaining disputed land east of Bayou Teche. They had been content with the land still in their possession west of the bayou, "living at peace with their neighbors," but Demarest and Nelson persisted. Refusing to elect Demarest as chief and to designate him as plaintiff in the *Delhaye* case, they were talked into electing Paul Nelson, "being an Indian," and into bringing the suit against their neighbors to court. The crux of the Chitimachas' defense was their charge that George Demarest and his co-plaintiffs in the present case were not members of the tribe. And now that the effort to recover land previously lost had failed in a federal court, these pretenders were trying to grab a large portion of remaining tribal land through a state court. A promise from Demarest that property west of Bayou Teche would never be disturbed, whether or not they won the *Delhaye* case, was now being undermined by his attempt to divide that very same property.

In stating that only about two of the fifty or so people in possession of the Chitimacha land could read and write, the defendants

aver that the said Demarest, and most of his co-conspirators, are educated, have attended the white schools, associate with and pass as white people; they aver further that they themselves were many years ago, barred from the white schools of their neighborhood, and refused to attend the negro schools, and being unable to provide their own schooling, grew up without education; they aver further that the said Demarest knew this, and took advantage of their unfortunate condition to involve them in a judicial admission whose consequence they

did not know—the said Demarest, for himself and his co-plaintiffs in the present action aforesaid, declaring to them, that all of the land being granted by one patent, that it were necessary that all of it be included in their declaration of ownership.

After staking this racial ground for themselves, the defendants finally addressed the plaintiffs' allegation that "the said property can not be divided, conveniently, in kind" and therefore must be partitioned. The "five acres of high, arable land, with an extensive front upon Bayou Teche, and through which the main public road runs," could be subdivided into small farms with the effect of increasing its value. In essence this would perpetuate how they, as rightful descendants of those whose exclusive ownership had been recognized long ago, were already using and improving the land.

A decision contrary to Chitimacha defendants' view of their land was delivered by Judge Albert C. Allen in Franklin on June 25, 1903, turning over to the plaintiffs 206.14 acres of land and leaving 261.47 acres for the defendants. Both parties had apparently already agreed to this division, with the plaintiffs assuming responsibility for paying their portion of the lawsuit's costs. "After a thorough canvass of the situation," according to their attorney Emmet Alpha, "the defendants offered the plaintiffs a compromise to the extent of four-ninths of the land to be divided in kind." The next step in this dispossession came when all the plaintiffs sold their interest in the judgment to George Demarest. In a notebook where Mary Bradford was drawing the various patterns on Chitimacha baskets and recording their names in both Chitimacha and English, she scribbled on a blank page, "220 acres gone to Geo. Demarest." But before the end of the year, Demarest—along with his attorneys whose fees had entitled them to an interest—sold the entire 206.14 acres to sugar planter Frank C. Viguerie.[18] Less than two years later, Emmet Alpha himself filed suit against the Chitimachas for fees charged to defend them against Demarest's suit. Judge Allen ruled in favor of attorney Alpha, awarding him a judgment for $678.50 with 5 percent interest. It was this judgment

that would threaten the community over the next decade with loss of all its land.[19]

In the meantime, as revealed in chapter 1, the Chitimachas had already found invaluable allies when in 1899 Chief John Paul had replied to Mary McIlhenny Bradford's inquiry about baskets, and his daughter-in-law Christine double-wove a large, lidded container for her. Only a few days before Christine Paul announced directly to Bradford the completion of this basket, asking twenty-five dollars for it, a newspaper report on the Chitimachas' ongoing suit in the U.S. Circuit Court ended with a notable description of the very same object: "Mrs Paul, daughter-in-law of the chief, is at work on a basket twenty-four inches long, sixteen inches wide and fifteen inches deep. It will be trunk-shaped, the inside lined with the reed cane in the natural color, and the outside having three different colors. It will be provided with a cover, and will be one of the largest fancy baskets ever made by the Chetimaches."[20] A trunk-shaped basket of this size, woven into shape with an elaborately designed exterior surface and a separate interior wall, was indeed the most difficult-to-create and most exquisite-to-behold representation of Chitimacha basketry. And with the arts and crafts market newly opening to Chitimacha weavers, special orders for sets of double-weave baskets made in different sizes and patterns posed an especially demanding challenge. "About the price of a nest of baskets," Christine Paul and Clara Darden reported to Mary Bradford, "we can not tell anything till we would get the work done, for we never made this kind of baskets in nests before. The big basket we made for you gave us more work than any of us had an idea of."[21]

While Christine Paul was leading the revival of basketmaking in her community, Mary Bradford began helping her turn this production of material objects to wider purpose. In the summer of 1902, Bradford became aware of plans at the Office of Indian Affairs and the Smithsonian Institution to feature Indian artisans at the forthcoming world's fair in St. Louis. She immediately began to arrange with government officials and anthropologists for

Chitimacha baskets to be displayed. A hope that some of the weavers themselves would travel to St. Louis was not fulfilled, but their basketry did appear prominently in several exhibits at the fair.[22] Most important for this discussion was how Bradford used this direct communication with Indian Affairs officials to solicit federal support for Chitimacha education. She had already sent appeals for educational assistance to various acquaintances, including Tulane University president Edwin Alderman, but here was an opportunity to reach the national government.[23] Samuel McCowan, superintendent of the Chilocco Indian School in Oklahoma, who also happened to be in charge of organizing the Office of Indian Affairs exhibit for the world's fair, responded to an inquiry from Bradford in September 1903 by doubting that it would be possible now to fund an industrial school at Charenton. He did suggest, however, that Chitimacha children could attend his school at Chilocco, sending copies of its magazine under separate cover. "Can't you interest these Indians in this matter and collect a class and bring them here?" he wondered. "I can pay all of your expenses for this work, or if you think best, I will visit these people myself and see what can be done."[24]

Less encouraging words came from Samuel McCowan's boss, Commissioner of Indian Affairs William A. Jones. In Washington, D.C., Bradford had apparently sent directly to Jones some communication between herself and the St. Mary Parish school board. His administration now took the position that the Chitimachas were citizens of the state of Louisiana and were therefore entitled to local public education rather than federal assistance. "As you are aware," Jones wrote, "the entire policy of the Indian Office is to make the Indian self-supporting and taking him from under the parental care of the general government. Where Indians have broken loose from this, it is not deemed desirable to re-establish the same. It seems to me that if these Indians are paying taxes, as stated by the superintendent of the Parish of St. Mary, they should certainly be furnished with some facilities for the education of their children." Bradford's appeal for a federal Indian school at Charenton obviously ran against the mainstream of U.S. Indian policy, but she

would relentlessly pursue an even wider campaign of finding help for the Chitimachas' ongoing struggle over land rights.[25] Escalating her inquiries and entreaties to the Office of Indian Affairs, Mary Bradford solicited help from Congressman Robert Broussard from Louisiana, a personal friend of her brother John A. McIlhenny. Commissioner Jones nonetheless stuck to his position, writing to Broussard at the end of 1903 that "these Indians have never been under Federal jurisdiction, therefore Mrs. Bradford will have to depend on the proper State records of Louisiana to ascertain the legal status of the claims of said Indians."[26]

On March 9, 1905, Christine Paul frantically wrote to Mary Bradford, "We are in truble with our land I don't know what they want do with us they trying there best to put us out." The Chitimachas had just received notice of the state court's ruling that they owed nearly $700 to Emmet Alpha for attorney fees. In this same pleading letter, which was accompanied by a copy of the judgment, Paul notably did not forget to announce, "we all stard working on our Basketry" after a bout of sickness since Christmas time and to ask if Bradford received "a lot of Baskets" sent last month. In addition to the state court's ruling in the claimant's favor came threatening words from his own mouth. If the sheriff did not evict the tribe, as Paul relayed Emmet Alpha's threat to Bradford on April 18, he would get authorities in New Orleans "to macke us go." To make matters even more distressing, "he say we not Indians because we mix so much. . . . He say we not a nation. I don't know what we are then if we not nation. I am sure we not dogs." Christine Paul also informed Mary Bradford about how sick and upset this latest crisis was making "poor old Clara Darden," who "say she raddy die then lose her place" and "ask me to ask you if lawyer had talke in New Orleans."[27]

This latest appeal for help from Christine Paul, of course, made Mary Bradford's campaign for the Chitimachas ever more urgent. Her older sister, Sara McIlhenny, joined robustly in writing to others for information and assistance, while St. Mary Parish scheduled a public sale of the Chitimachas' land for April 22 in order to satisfy the debt to Alpha.[28] Thanks to outside pressure, the land

auction was postponed indefinitely, so the McIlhenny sisters now escalated their efforts in helping Chitimacha children enroll at the Carlisle Indian School. From 1906 to 1913, twenty would attend this government boarding school in Pennsylvania, mostly for terms of five years each. Before long, these students and their parents were using this formative relationship with the Office of Indian Affairs as another way to communicate their dire need for federal attention. "The children bring pitiful tales of their mistreatment," as Carlisle's superintendent reported to Commissioner of Indian Affairs Robert Valentine in 1910.[29]

Relationships that Chitimacha women forged with anthropologists, largely through their basket trade with the McIlhenny sisters, added even more to the formation of what increasingly looked like a new kind of Indian alliance network. John Swanton, from the Smithsonian Institution, visited the Chitimachas for the first time in 1907 and again in 1908. As Christine Paul reported to Mary Bradford after Swanton's initial visit, he spent a week with her husband, Ben, wanting to hear their language and old stories. Between these two trips by Swanton, Mark Raymond Harrington traveled to Charenton under the employment of George Heye. Representative of ethnographers at the time, both Swanton and Harrington were eager to collect cultural objects as well as to learn about language, oral tradition, and ceremonial life. Bradford eagerly facilitated their efforts to purchase Chitimacha basketry for their respective employers. Although authenticating material artifacts and cultural practices was unfortunately motivated in large part by the belief that Indians were a vanishing people, the Chitimachas were remarkably adept at mobilizing contemporary ethnographic practice to gain more support in their urgent struggle for government protection and public interest. Knowing that Swanton came from Washington but thinking it impolite to ask him directly, Christine Paul naturally wanted to learn from Bradford why he was "hunting for Indians."[30]

Days before Mark Harrington reached Charenton, the Chitimachas suffered another devastating loss to local violence

and injustice. "White people kill my poor brother in law," Christine frantically wrote to Mary, reporting that Jules Darden—whose wife had been shot in the Christmas 1901 murders—was brutally stabbed to death in a fight at the Veeder brothers' store and bar on February 22, 1908. John and George Veeder apparently ganged up on Darden, but a grand jury saw no probable cause to support the charge of manslaughter brought against John. Not incidentally, John and George were sons of Alcide Veeder—a defendant in the 1896 Chitimacha federal lawsuit—and George would be elected to the Louisiana State House of Representatives months after the killing of Jules Darden.[31] Before Harrington left the Chitimachas in April, he recorded details about both the 1901 and 1908 murders— as told to him by Benjamin Paul, Christine Paul, Delphine Stouff, and Octave Stouff—and promised to relay their account to the Indian Office. The arrival of Harrington's report on the commissioner of Indian Affairs' desk initially sparked enough interest for him to consider asking the governor of Louisiana to "look into this matter to see what can be done to protect the Indians." But rather than send such a direct request, acting commissioner William C. Farrabee replied to Harrington that "the Office has no jurisdiction or responsibility concerning these Indians, and it is suggested that you bring the matter to the attention of the Governor of the State."[32]

Weaving a network of relations to overcome Indian Office negligence became increasingly urgent for the Chitimacha people, as the debt lien on their land exchanged hands between neighboring whites. Through a series of speculative transactions, Frank C. Viguerie—the same planter who had purchased George Demarest's partitioned interest in Chitimacha land in 1903—acquired attorney Emmet Alpha's judgment against the Chitimachas. By 1912 Viguerie was demanding seizure and sale for default, now valued at about $1,200.[33] More relentlessly than any other sugar planter, Frank C. Viguerie had been gaining possession of Chitimacha land for some time. The son of a prominent sugar planter, he married into the Burguieres family in 1885 and thereby gained access to several of the region's most profitable plantations and refineries.

Law courts across Louisiana's sugar bowl were busily occupied with deceptive arrangements and contentious disputes during these years, and Viguerie's acquisition of land once owned by the Chitimachas fit squarely within this pattern.[34] The plight of this American Indian people was, therefore, a central story in the New South. By the beginning of the twentieth century, Viguerie already operated sugar production on land situated between Bayou Teche and Grand Lake—land lost by the Chitimachas through sales dating before the Civil War, yet still being used for hunting, fishing, and gathering. Viguerie's production of sugarcane along Grand Lake, along with his development of Charenton Beach into a popular resort for whites, also drastically reduced sources of basketry cane around a lake still held sacred by the Chitimachas.[35] With his purchase in 1903 of the land lost by them in *Demarest v. Nelson* and his acquisition now of Emmet Alpha's judgment, Viguerie was about to dispossess the Chitimachas of their remaining acreage on the west side of Bayou Teche.

While planters and attorneys were speculating in Chitimacha debt, Christine and Benjamin Paul were taking on heavier responsibilities in their besieged community. Although they had no children of their own, they brought orphaned and other needy youth into their care. When Jules Darden was killed by the Veeder brothers in 1908, the Pauls adopted his son, Arthur, who as a baby had already lost his mother, Virginia, when she died a year after the sheriffs' attack on Christmas Day 1901. The winter of 1906–7 was perhaps an especially weary passage of months for the family of Christine and Benjamin Paul. Worried that Delphine Stouff was getting hold of basket money that belonged to Clara Darden, Christine Paul beseeched Mary Bradford not to communicate directly with other tribal members about the basket business. Although Stouff had been raised by her grandaunt Clara, she was not willing to make baskets herself, and Darden was at that time living with the Pauls. In December Christine Paul cut her hand and fell ill, delaying completion of Bradford's latest orders for baskets. Bradford was even pressing her to label everyone's baskets with its price and the name of its weaver "because then I will know who to order to make the

baskets [and] the one that makes best will get the most orders." With her own health improved and a sick child getting better, Paul returned to making her own baskets by late January.[36]

Amid these stressful demands and further complicating personal relationships, Delphine Stouff's young son underwent surgery on one of his feet, performed in New Orleans by Dr. Paul Avery McIlhenny. A brother of Mary Bradford and Sara McIlhenny, Paul McIlhenny had very recently brought from the University of Berlin the South's first X-ray machine designed for orthopedic use. Several months after the operation, Bradford complained to Christine Paul about Stouff failing to send the monthly payments of ten dollars that she had promised in order for Bradford to pay her brother for the expensive procedure. If Delphine Stouff did not make an initial payment right away, she warned, Dr. McIlhenny "will collect it through a lawyer as he wrote them it is money he has paid out." And as Bradford emphatically noted, "Delphine does not make baskets so she cant pay me back in baskets as the rest of you can." But by next spring, lo and behold, Christine Paul was sending to Mary Bradford a selection of baskets made by Delphine toward payment of her debt. More would soon follow, Paul reported to Bradford, along with Delphine Stouff's hearty thanks for "your kindness you have to wet so long on her."[37]

In face of the gravest threat to the Chitimachas' remaining land—Frank Viguerie's demand of seizure for debt early in 1912— it was none other than Delphine Stouff who wrote a special appeal to Mark Harrington, the anthropologist from New York who had visited Charenton four years earlier. Unquestionably a busy and skilled basket weaver by then, Stouff understood that the federal government had authority to protect Indian lands against alienation, but unfortunately it was paying her people no mind. Although "some said we not Indians," she thought that Harrington could prove otherwise. "You know yourself you come here and borth [bought] old thing we had made by my parents." Hoping the anthropologist could appeal to Congress on the Chitimachas' behalf, Delphine Stouff declared that "we are Indian too," thus deserving "the same right like orther Indians."[38] Ascribing political agency to

objects that anthropologists treated as cultural artifacts, Delphine Stouff's letter was forwarded by Mark Harrington to his Seneca Indian friend Arthur Parker. Secretary of the newly organized Society of American Indians as well as an archaeologist and ethnologist at the New York State Museum, Parker then sent his own appeal to Commissioner Cato Sells on behalf of the Chitimachas and published Harrington's account of the Chitimacha murders in the society's quarterly journal. Mark Harrington also sought help from the Indian Rights Association, saying to Executive Secretary Matthew Sniffen, "I certainly hope the Chetimachas will not be driven from their homes. . . . They deserve a better fate. You have doubtless seen their exquisite cane baskets, whose soft native dyes and beautiful patterns are the best of their kind."[39] Pauline Paul— another skilled basketmaker, sister of Chief Ben Paul and a former student at Carlisle—wrote to that school's superintendent, Moses Friedman. She asked for the same rights that other Indians in the United States possessed, wondering if Congress might do something to save the "last little sport we on where we live right now." Pauline's sister-in-law, Christine, addressed her own letter to the supervisor in charge of Indian schools, H. B. Peairs, saying "they don't like Indian around here so we wish to know how we stand."[40]

While Christine Paul and other Chitimacha women were working their own lines of communication, Mary Bradford and Sara McIlhenny utilized channels that their highly regarded circulation of Chitimacha baskets had already opened. After McIlhenny sent an account of the Chitimachas' dire situation to the Reverend William Brewster Humphrey, executive secretary of the American Indian League in New York City, he contacted educator-philanthropist James H. Dillard. "Mrs. Bradford and her sister Miss McIlhenny have been the steadfast friends of these Indians for many years," Humphrey wrote. "They have interested our American Indian League in finding a market for their basketry product and for a good many years now this organization has been doing what it could for them along this line."[41] With a date once again set by St. Mary Parish for auctioning Chitimacha land, the McIlhenny sisters

turned to their brother John McIlhenny for extra help. As head of the U.S. Civil Service Commission in Washington, D.C., John McIlhenny's phone calls and letters to Indian Office officials, congressmen, and activists certainly did not hurt. "Members of my family have for a number of years taken a charitable interest in this remnant of a once powerful tribe," he wrote to Commissioner Sells, "and have sought by every method within their limited means to safeguard their interests."[42]

Sara McIlhenny responded in an emotionally fraught manner to questions from Charles Dagenett, supervisor of Indian employment in the Office of Indian Affairs and a founding member of the Society of American Indians. Asked if the state government provided educational and other support to the tribe, she explained that "the law of Louisiana forbids the attendance of colored children in schools for white children and the Chetimaches refuse to send their children to the public schools for negro children, holding themselves as a superior race, and realizing that intermarriage with negroes would mean their extermination." McIlhenny then recalled her own success in arranging for some twenty Chitimacha children to attend Carlisle but also reported that several died of pneumonia or consumption at the school or soon after returning home and that others "were restless and discontented, after their return." "I am not sure," Sara lamented, "whether I acted for their betterment or not." Regarding additional pressures felt by the Chitimachas, she wrote, "The needy, sick and orphans all turn for help to the Chief and his wife, who is a most unusual woman." "They have never received any help from the State nor from any individual to my knowledge," McIlhenny added, "except small advances to the women weavers, in time of sickness and need, by Mrs. Sidney Bradford and by me, which they have always repaid in baskets." She referred Dagenett to John Swanton at the Smithsonian for more information about the tribe and then closed her letter "hoping for some help, for a helpless people."[43]

The Indian Rights Association was the most promising front in this scramble for money to pay off the Chitimachas' debt. This national organization was founded in 1882 to advance civilization

and citizenship for American Indians, and it also devoted significant attention to improving their economic and legal conditions. On receiving notice about the Chitimachas' situation in Louisiana from different sources, the Indian Rights Association's agent in Washington, Samuel M. Brosius, worked energetically to gather information and assemble funds. Brosius attempted to mobilize both the Office of Indian Affairs and the U.S. attorney general to assist the Chitimachas—against tremendous odds—while also seeking funds needed to satisfy the tribe's creditor. Close to assembling enough contributions, mostly from Indian Rights Association patrons in Philadelphia, Brosius at the last minute decided not to proceed because of deepening suspicion toward the motives of Charles J. Boatner, a Franklin, Louisiana, attorney representing the Chitimachas. Considering the stunning record of deceit and abuse that led to the Chitimachas' current plight, this was not an unreasonable apprehension. For negotiating some way out for the tribe, Boatner apparently expected a fee of $500—an extremely unfair amount for such service, according to Civil Service Commissioner John McIlhenny's communication with Samuel Brosius.[44]

This breakdown in the Indian Rights Association's aggressive campaign on behalf of the Chitimachas, however, left John McIlhenny's sister Sara no choice but to scrape together her own resources just in time for the impending land sale. So on the morning of March 13, 1914, U.S. District Attorney Walter Guion left his office in the New Orleans Custom House with a check for $1,240 signed by Miss Sara Avery McIlhenny. He rode the Canal Street ferry across the Mississippi River, boarded a Southern Pacific train at Algiers Point, and headed west for Bayou Teche country. By the end of that afternoon, Guion was rushing from the train station in Franklin, Louisiana, for the St. Mary Parish courthouse. There he presented the check to an attorney representing the Chitimachas' creditors, stopping seizure and sale of their remaining 260 acres.[45]

Now as purchaser of judgment for the Chitimachas' debt, Sara McIlhenny immersed herself even more deeply in community

affairs over the next few years. Partly because of illness, Mary Bradford became less involved. Arrangements were made for leasing portions of land, paying Boatner's attorney fees, and reviving McIlhenny's judgment to preempt foreclosure. In the thick of this legal business, she relentlessly urged Chitimacha women to weave baskets. "Send me all the baskets you can get from all the people, as soon as possible," Sara McIlhenny wrote to Christine Paul as the year 1915 began, even indicating an opportunity to exhibit some at the upcoming world's fair in San Francisco. Meanwhile, legislation moved through Congress that would culminate in reimbursement for McIlhenny's loan and establishment of federal trust over Chitimacha land.[46] Toward the end of this process, Sara McIlhenny was forced to address a charge made by Charles Boatner that she had been overpaid nearly $500. She reminded the commissioner of Indian Affairs about her visit to his office, in the company of her brother John, when it had been agreed that "money collected from the rental of their lands would be held for the benefit of the Indians, & not to reimburse the Government." McIlhenny then expressed a less-than-flattering attitude toward the Chitimacha people. "I am the only person familier with the needs of these Indians & to whom they turn in sickness or trouble of any kind & I have disbursed most of the money in my hands for their benefit as I have seen fit. I have still a small amount in bank for their account, but if you are familier with Indian characteristics you must know it is not wise to tell them of any fund that they can count on, or it will soon be exhausted."[47] In their basketmaking relationship with the McIlhenny sisters, Chitimacha people undoubtedly suffered condescending judgment by even their closest allies. The chance of achieving better legal protection, however, probably outweighed the challenge of hurtful racial derision.

Following a century of dispossession by white neighbors and neglect by the U.S. government, the Chitimachas were at last able to reach allies and authorities willing to help their community survive. And central to this effort was Christine Paul, who through

both weaving baskets and writing letters responded vigorously to a new kind of interest in Indian arts and crafts. Even before Mary Bradford first inquired about surviving basket weavers in their community, Chitimacha people had begun to suspect that a craft suddenly appreciated by distant collectors could hold political as well as economic promise. In a neighborhood still hostile to the Chitimachas, Mary Bradford and Sara McIlhenny became nearby patrons who generously assisted in not only marketing their cultural objects but in communicating their political needs to an array of outsiders. When confronting creditors determined to take the remainder of their lands early in the twentieth century, Chitimacha basketmakers secured an invaluable alliance with these other Louisiana women on Avery Island. By creatively responding to aesthetic and ethnographic interest in their material culture, Chitimacha Indians gained access to influential public attention at a most precarious time in their history.[48]

Chitimacha participation in the Indian arts and crafts market overlapped with many other ways that Indian people a century ago mobilized public fascination and amusement to achieve their own economic and political objectives. Through various responses to the dominant society's quest for an "authentic" Indianness— whether performing in wild west shows or early motion pictures, dancing at world fairs or national parks, posing for painters or photographers, selling pottery or jewelry in town plazas, or collaborating with anthropologists or musicologists—Indian people intended to self-represent some of their own interests in the face of controlled representation by non-Indian outsiders.[49] The objectives pursued by Indian performers and producers were as diverse and dissonant as were the objectives of white observers and collectors of Indian culture. By carefully forming and maintaining relationships with admirers of Chitimacha basketry, Christine Paul ventured onto a striking example of what Frederick Hoxie called "Native American journeys of discovery, journeys devoted to the search for a new home in a captured land." Among outsiders posing as new "discoverers" of American Indian culture, many

Indigenous people found resources and paths for "their own voyages of exploration" into the twentieth century.[50] The preservation of the Chitimachas' land base and the recognition of their federal status—acquired largely through the production of baskets—set this south Louisiana Indian tribe on a voyage naturally mixed with new hopes and hazards.

"Language of the Wild Things"

❧ ❧ ❧ ❧ ❧ ❧

Caroline Coroneos Dormon,
New Deal Naturalist

"Since I have been old enough to learn the facts concerning them," Caroline Dormon wrote in 1945, "the Indians have constituted a heavy burden on my heart. The tragic thing is that so very few persons know the *truth*." Given "the vast ignorance concerning these people," she was "sure that the enemies of the Indian—the people who want his land—have deliberately built up a tissue of lies; and these lies have been repeated down the years, till they are now accepted." These passionate words sent to the then outgoing commissioner of Indian Affairs John Collier came from the best known of the three southern women featured in this book.[1] But among Caroline Dormon's many accomplishments as a teacher, conservationist, naturalist, illustrator, and even archaeologist, her very close alliance with the Chitimacha Indians remains the least noticed experience in her life history.

Caroline Dormon is, nonetheless, recognized for bringing Chitimacha Indian basketry to public attention in a significant way because of an article she wrote for the October 1931 issue of *Holland's, the Magazine of the South*. "The Last of the Cane Basket Makers" appeared in this popular magazine some thirty years after Mary Bradford had begun her relationship with Christine Paul. And not incidentally for my story, a three-decades-older Christine is one of four different Chitimacha women shown with baskets in the article's photographs. Dormon begins her essay wondering

why, except for "this tiny Indian village" on Bayou Teche, the once-great nation of the Chitimachas, has disappeared. "Like most of our primitive people," she hastens to answer, "they could not withstand the rude shock of contact with our civilization." Among the survivors at Indian Bend, however, the "charming ancient art" of basketry is still preserved by a "half dozen Chitimacha women." "What strange pride of race," she further wonders, "has held this remnant of a tribe true to their ideals, to unchanging standards, through all the wearing down of contact with alien peoples?" The bulk of Dormon's article describes how the women gather and prepare the cane, dye splints with black walnut and dock root, and weave them into intricate shapes and designs. Then she points out that the Chitimachas would probably have abandoned such exquisite work, as did so many other southern Indians, "had it not been for the interest and encouragement of Miss Sarah McIlhenny and her sister Mrs. Sidney Bradford," who "helped these Indian women to market their baskets, and befriended them in many ways." The newcomer entering this "quiet backwater, surrounded by the surge of modern progress," is still greeted by Chitimachas with polite caution. But if able to "prove himself" and win their confidence—"not so quickly done"—"one finds intelligence, humor, and friendliness."[2]

The nostalgic and even elegiac tone of language used by Caroline Dormon in this widely read article, along with her failure to name the Indigenous women pictured in the accompanying photographs, gives us some cause to wonder if she herself proved to be a true friend or effective ally of the Chitimacha people. After all, wasn't Dormon simply perpetuating in "The Last of the Cane Basket Makers" a depersonalization of Indian artistry still so common in ethnographic and romantic gazes? And was to "breathe a prayer that modernism may never touch them," as she puts it at the end, really going to help perpetuate a market for Chitimacha baskets?

The north Louisiana that Caroline Coroneos Dormon was born into on July 19, 1888, was a very different world from the south

Louisiana of Mary McIlhenny Bradford and Christine Navarro Paul. Her father, James Dormon, was a lawyer with a modest but respectable practice, and her mother a writer of poems, short stories, and one novel. The family lived in Arcadia but spent most summers at Briarwood, their cottage in the piney hills of northern Natchitoches Parish, where Caroline and her sister, Virginia, absorbed their parents' passion for local nature and history. After earning a degree in fine arts at Judson College in Marion, Alabama, in 1908, "Carrie"—as she was called by family and friends—taught high school music and art for about ten years. Then, after both of their parents passed away, Caroline and Virginia moved to Briarwood for good. From a small log cabin newly built on the property, Dormon channeled her creative teaching skills into a career of conservationism and botanical education. As chair of conservation for the Louisiana Federated Women's Clubs and a member of the Louisiana Forestry Association's legislative committee, she was appointed by the state's commissioner of conservation to work with public relations for the forestry department and thus became one of only few women to attain employment in forestry at the time.[3] Establishment of a national forest in Louisiana became Dormon's most ambitious goal, wanting to protect longleaf pine trees threatened by an aggressive logging industry. Intolerance toward bureaucratic oversight caused this independent-minded woman to resign from the forestry department within two years, but the forestry education program that Dormon designed for Louisiana public schools had already become a model for neighboring states, and she continued to campaign for a national forest in Louisiana. In 1930 Congress set aside seventy-seven thousand acres as the Kisatchie National Forest.[4]

By the late 1920s, however, Caroline Dormon took up an additional cause, busily seeking information and assistance on behalf of her state's Indians. And now with this more distantly located white woman, the Chitimachas eagerly began to weave a strong personal relationship, as they had done earlier with the McIlhennys. Perhaps once again, anthropological and aesthetic interest in their unique baskets could be put to multiple uses. Mainly

through Dormon's help, sure enough, they established ties with a new generation of ethnographers and collectors, started a tribal school where basketry instruction would occur, and navigated through economic and political trials. In important ways, Caroline Dormon was better prepared and connected than Mary Bradford and Sara McIlhenny could ever have been for the tribe's ongoing pursuit of governmental support. For in addition to facilitating the sale of Chitimacha baskets and the study of Chitimacha culture, she became their broker with the Indian New Deal, which itself was a significant departure from federal Indian policy faced earlier by the McIlhenny sisters.

Upon receiving from Caroline Dormon a copy of her article published in *Holland's*, Pauline Paul wrote back on November 4, 1931, "The magazine is fine. I belived its called for more works in the baskets business." In the same letter, Pauline—now fifty years old—acknowledged receipt of a five-dollar money order and indicated that she was sending a tray-shaped basket the same day. "Let me know if it is the kind you wants," she added.[5] As this exchange suggests, the basket business now mediated by Dormon closely resembled the patronage of Mary Bradford three decades earlier. Mary, despite her apparent desire to do so, had never managed to publish anything about Chitimacha basketry, although information that she provided ethnologists and circulated among others certainly helped generate invaluable interest at the most critical moment.

Now it was Dormon who regularly ordered baskets from sisters-in-law Christine and Pauline Paul. In the earliest extant record of such a transaction, Christine apologized on New Year's Day 1930 for sending some cigarette cases later than promised. She was unable to "work on them when its so cold." Later that year, Pauline reported to Caroline, "We are all well at the present, and all are at work. Benj. is making a boat. I am working on the Basket[s] and try to not make one alike. I have twelve of them made." In another letter she informed Dormon about a basket that came out larger than requested for the price of five dollars but could not start another one because the cane dried up. "We have to work them when [they] are green."[6] Interwoven with information about baskets-

in-progress were updates on family and community matters, especially the worsening condition of Benjamin Paul's health and the deepening effects of the Great Depression. In 1932 Ben spent seven weeks in New Orleans Charity Hospital, suffering apparent symptoms of diabetes and cataracts, while Christine Paul worried over how they would "get along in this hard time." "I don't know how is over there," she wrote to Dormon, "there is no work here its very hard."[7] After her husband died two years later, with her adopted sons getting married and herself frequently falling sick, Christine notified Caroline that she would gladly sell more baskets. "That all Pauline [and] I can get for living right [now]." When those words were written in July 1936, they were anxiously waiting to learn if John Swanton at the Smithsonian would buy the twenty dollars worth of baskets he had ordered and were ready to be sent.[8]

Over the decades of the 1920s and 1930s, Christine Paul's communication with the McIlhenny sisters had faded into only occasional orders for baskets and inquiries about health. One of the latest sparks of merchandising occurred in 1932, when Sara reported to Christine that her cousin in Philadelphia found a place there that wanted to sell baskets for them, and Mary sent the set of double-woven baskets made decades earlier by Clara Darden to Harvard University's Peabody Museum of Archaeology and Ethnology. "We are very much pleased to have them in the Museum," Peabody director Donald Scott wrote to Mary, "particularly since you have so carefully documented their making. We will see that the references which you have given us are so listed that they will be readily accessible to anyone who has occasion to study this culture."[9] By then Bradford's relationship with the Chitimachas, as seen in chapter 1, was centered on efforts to fund a commemorative headstone for Clara Darden's grave. In 1934 she visited Charenton and was joined by tribal members to ceremoniously place the engraved stone in the Catholic cemetery. The latest extant letter from Sara McIlhenny to Christine Paul was written on March 18, 1937. "I wrote to you, from New Orleans," she reminded Christine, "asking you to send some small double weave baskets to the Christian Women's Exchange, 524 Royal St. New Orleans, but

I have not heard from you." McIlhenny enclosed a check for five dollars "for some baskets the Exchange sold for you last month." Mary Bradford's last correspondence with Paul, on record, was a brief letter dated December 15, 1939, that forwarded a check sent by "the kind ladies [in West Virginia] who always remember you at Christmas."[10]

Caroline Dormon, meanwhile, became instrumental in assisting the latest anthropological fieldwork undertaken among the Chitimachas and other Louisiana Indians, repeating another role played earlier by Mary Bradford. Unlike Bradford, however, Dormon took a much deeper and wider interest in the study of American Indian societies. From her firsthand knowledge of north Louisiana land, as a naturalist and outdoorswoman, Dormon came to appreciate many important ancient sites across the region and campaigned for archaeological attention before their further destruction. Thanks to WPA funding for such work, she was able to help archaeologists locate and excavate several mound complexes in the Ouachita and Red river valleys. And when it came to living Indians, Dormon turned to the very same Smithsonian ethnologist whose early fieldwork had benefited so much from Mary Bradford. Dormon's appeal to John Swanton, though, was motivated by concerns beyond Chitimacha basketry, beginning with her request for titles of ethnographic and linguistic work on Louisiana Indians in early 1929. Within months into a relationship that also seemed more reciprocal, Swanton was reading drafts of stories that Dormon wrote, and she was assisting him on his latest fieldtrip to the state.[11] For the first time in Swanton's periodic visits to Louisiana, and with plenty of help from Dormon and her sister, this anthropologist was able to travel by automobile across some of the state's newly built roads. As he reported about work done in the summer of 1930, "through the kind cooperation of Miss Caroline Dormon, of Chestnut, Louisiana, a leader in movements for the conservation of the natural resources and antiquities of this commonwealth, and her sister Mrs. Miller, who acted as chauffeur in the various expeditions which were undertaken,

nearly all groups of Indians in that part of Louisiana west of the Mississippi of whom knowledge could be obtained were visited and accurate information was secured regarding the remaining ethnological possibilities of the section."[12] Regular communication over Dormon's own research and knowledge generated enough respect for Swanton to invite her six years later to represent Louisiana on the DeSoto Commission, a congressionally authorized and presidentially appointed group that would spend three years tracing the Spanish conqueror's route across the Southeast.[13]

Between stretches of studious reclusion at Briarwood and stints of strenuous fieldwork on the road, Caroline Dormon spent much of her most pleasurable time at the plantation home of her friend Carmeline Garrett Henry. Located about fifteen miles from Natchitoches, Melrose was an antebellum plantation along Cane River that "Cammie" Henry had restored and turned into a colony for writers and artists. Regular visitors to this spacious and scenic retreat included Lyle Saxon, Ada Jack Carver, Roark Bradford, William Spratling, Alberta Kinsey, and Caroline Dormon. One of the plantation's domestic workers—serving provision and comfort to these guests—was Clementine Hunter, who would eventually become famous for her own artwork. A patron of natural preservation as well as of artistic pursuits, Henry assisted Dormon in gathering, studying, and cataloguing native plants—most notably the varieties of iris found in Louisiana.[14]

When not out alone painting flowers or birds around Melrose plantation, Dormon engaged in conversation with visiting writers and artists over a wide range of topics. But she must have found special delight in the critical success attained by Ada Jack Carver, a Judson College classmate, for her short story about local people of American Indian descent, "Redbone," published in the February 1925 issue of *Harper's Magazine*. Later on, Dormon would also be pleased by the substantial coverage given to Indian communities in *Louisiana: A Guide to the State*, produced under Lyle Saxon's directorship of the state's WPA Federal Writers Project.[15] In the New Orleans French Quarter, where Saxon's primary home was located, his many literary companions included William Faulkner and

Oliver La Farge. Faulkner was starting to imaginatively populate many of his stories with unforgettable Choctaw and Chickasaw characters. La Farge began to write his Pulitzer prize–winning novel, *Laughing Boy*, featuring Navajo characters, and would soon become president of the Association on American Indian Affairs and an advocate of American Indian arts and crafts.[16] Dormon's friendship with Saxon is reflected in their regular correspondence as well as in her profile of him appearing in *Holland's* several months before that same magazine published "Last of the Cane Basket Makers."[17] Her close relationship with Cammie Henry can be glimpsed in one letter that she sent from Briarwood after having assisted Henry through some convalescence at Melrose. "Now you are better, I'm trying to remember to tell you where things are, and what I did," Dormon wrote in April 1936. These directions to Henry included "Your green cotton is in the paper sack in your Indian work basket at the 'Shop.'"[18]

In the early 1930s a new generation of ethnologists and linguists began innovative fieldwork among Louisiana Indians, with plenty of assistance and guidance provided by Caroline Dormon. The husband-wife team of Morris Swadesh and Mary Haas, PhD students from Yale, spent summers among the Chitimachas and Tunicas, respectively. An especially talented linguist, Swadesh worked closely with Chief Ben Paul and his niece Delphine Stouff, the only speakers of Chitimacha in the community. He quickly realized the value of Dormon's relationship with the basketmaking families and of her own informal fieldwork among them. "Benjamin had mentioned you before," Swadesh wrote her in July 1932, "and I could not help but think you courageous for attempting to catch and record native terms, for the language is indeed difficult to hear." Becoming a bearer of messages between Dormon and the Pauls, Morris relayed Benjamin's request "to tell you that he is feeling much better since he came back from the hospital." "His eyesight has come back in part but he cannot distinguish things at a distance nor make out small things, as for example the Mouse Track basket design, even when close up." Swadesh closed this letter by asking Dormon, "Do you have a record of the word for

wax myrtle, arbre à cire? Benjamin says he gave you the word once, and he has now forgotten it himself."[19]

Following Swadesh's initial visit to Charenton, musicologist Frances Densmore spent about a week collecting songs and stories there in January 1933. Densmore characterized the households of Ben and Christine Paul, Delphine [Ducloux] Stouff, and Ernest Darden as "the nucleus of the band." "They were nearest to the old customs," she observed, "yet they wanted the younger generation to progress in the white man's way." Densmore further noted that Chitimacha basketry "has been encouraged and made profitable through the interest of white friends in the vicinity, and the best basketmakers were in the little group of Benjamin Paul's relatives." Although the ethnomusicologist discovered that "all songs have been forgotten" by the Chitimachas, she did manage to learn that Ben Paul remembered hearing his grandmother sing while digging medicinal herbs. He also "related legends in which songs were formerly interpolated." Along with several of these stories, Densmore left Charenton with "numerous specimens of basketry" and "many photographs."[20]

Among many stories collected by linguist Morris Swadesh were two worth summarizing here. Ben Paul told him about the origin of basketmaking among the Chitimachas. A girl walking on a road was struck by an unfinished basket falling to the ground and heard a voice saying, "Weave that basket! Finish it up!" Although people doubted her when she reported this incident and even wondered if "she [was] losing her mind," the girl completed work on the basket. On subsequent journeys, she learned how to weave more baskets from the holy woman in the woods and began to teach her people. "It was because that girl was a virgin that she learned rapidly," according to Paul. "Since then the Indians that are here worked those baskets." And whenever women entered a patch of river cane, they selected cane with joints showing thumb prints of the holy woman. "That cane is all good" for making baskets, noted Paul. In a separate story Delphine [Ducloux] Stouff recounted to Swadesh how, more than forty years earlier, she had learned to weave baskets. Not wanting to hurt her hands and not liking work, she refused to

learn until becoming a grown girl. Only after attending a school in Charenton run by Catholic nuns and learning about work there, "did I see it would be better if I wove baskets." So Stouff learned how to make baskets from her mother, who told her "if you do as I do, you too will have money as I." She had kept on weaving ever since.[21]

Caroline Dormon developed an especially close ethnographic partnership with Mary Haas, who, between her own ethnographic trips to the Tunica Indians in north Louisiana, stayed with her husband, Morris Swadesh, at a boarding house in Baldwin, downstream from Charenton along Bayou Teche. Upon learning that Haas collected some songs from her Tunica informant, Sam Young (Sestrie Youchigant), Dormon wrote to her:

> I've gotten only a few dance-songs from the Choctaw. Now listen . . . and be discreet! Make Delphine get off with you privately and sing the grandmother song . . . a little teasing song that children sang. Pauline can't sing a note, but she told me the words to it . . . perfectly innocuous, but somebody (probably B. Paul) reproved her, and told her it was a "bad song"!! She came to me afterwards and blushingly told me! It begins something like this "hä hoom tee, teek tok-tok . . ." (kindergarten phonetics) But DON'T TELL even DELPHINE WHO TOLE YOU ABOUT IT. Pauline would never have any more confidence in me . . . you know they have rigid ideas about things. I hope you can get it, for it sounded most unusual to me . . . particularly when you consider that most people think Indians have no fun about them.[22]

This sharing of advice and information between Dormon and Haas continued for several years, with stops at Briarwood made once in a while during the linguist's busy travels to different Indian communities in Louisiana, Texas, and Oklahoma. Whether corresponding over Indian place names in the DeSoto chronicles or over the location of isolated native speakers, Caroline Dormon encouraged Mary Haas to concentrate on Louisiana and volunteered to help with her research. "I believe you will make a mistake not to come see my Choctaw, Koasati, and Alabama," Caroline exclaimed, reminding Mary in 1938 about individuals and communities she

had been mentioning for some time. And pointing out that there are Alabama and Koasati people near Kinder, Louisiana, "who cannot speak English," Dormon wondered how Haas could complete her study of Creek Indians without including "these closely related languages."[23]

Amid a busy schedule of facilitating the handicraft, archaeological, and ethnographic work of other persons, Caroline Dormon managed to complete *Wild Flowers of Louisiana*, her first book, and "Caddo Pottery," an article in *Art and Archaeology*—both published in 1934. Dormon made sure that her very accessible guide to wildflowers—beautifully illustrated with her own drawings and paintings and highly regarded even to this day—included references to how American Indians used certain plants. Under swamp dock, *Rumex verticillatus*, in the buckwheat family of flowers, Dormon wrote, "The Chitimacha Indian name (southern La.) for it is 'Po-wah-ahsh,' which means 'deer's ears,' no doubt referring to the shape of the leaves. The Indians use it in dyeing their cane baskets."[24]

Generally less appreciated than *Wild Flowers of Louisiana*, Dormon's published essay on Caddo pottery admirably reflected her own toolkit of skills as a researcher, writer, and illustrator in the field of archaeology. To readers of the journal *Art and Archaeology* she provided an original and thorough analysis of pre-Columbian ceramics from the lower Red River Valley accompanied by her own drawings of bowls, bottles, and decorative designs. Dormon acknowledged that some patterns on Caddo pottery resembled those on pottery produced by the neighboring Natchez but emphasized the distinctive beauty of Caddoan ware, "decorated with meanders and spiral designs, set off by cross-hatching or transverse lines." "For sheer grace and artistry," she concluded, "aboriginal sites in the United States have yielded nothing finer."[25] Although no reference to basketry was made in Dormon's article, John Swanton published in the following year an essay that explicitly connected the artistic excellence of Chitimacha weaving to the aesthetic superiority of ancient Indians in the lower Mississippi and Red river valleys. "It is perhaps not accidental," he conjectured, "that the

Chitimacha, who retain the best technique, were near neighbors of the Caddo who seem to have surpassed all other tribes in their ceramics." In summarizing recent accomplishments in southeastern archaeology, Swanton recognized some of the same archaeologists cited by Dormon in "Caddo Pottery." He did not, however, mention her at all, indicating perhaps that this woman contributing so much to new work in excavation and ethnology was still viewed as a professional outsider.[26]

For the Chitimacha people along Bayou Teche, however, it was Caroline Dormon's communication with government officials that mattered most. Once again, a white woman keenly interested in their well-being as well as in their culture served as an invaluable ally in ongoing efforts to solicit federal protection and support. The establishment of trust status over their land in 1916—the political outcome of the McIlhenny alliance featured in chapter 2 of this book—saved the Chitimachas from further loss of territory but hardly solved all their social and economic problems. Suspicion over some families benefiting more than others from rental of tribal property mounted during the 1920s, and dispute over alternative uses of the land only intensified as other sources of income dried up with the Great Depression. Charles Boatner, the Franklin attorney who had represented the Chitimachas in their land crisis, continued to serve as intermediary between the tribe and the federal government into the 1930s. He handled annual distribution of leasing revenues, negotiated new terms with prospective lessees, and relayed requests for information between tribal members and the Office of Indian Affairs.[27] But throughout all of these new challenges, Christine Paul persevered in her role as mediator and voice for her people. Visits to Franklin, Louisiana, and letters to Washington, D.C., regularly interrupted her other responsibilities—including the manufacture of baskets. As Benjamin Paul announced to Assistant Commissioner E. B. Meritt in 1922, "My wife she is one doing the Indians business."[28] With plenty more political work to be done, weaving alliances with women outside the community continued to have value.

When Caroline Dormon began pursuing anthropological information about Louisiana Indians from the Smithsonian's John Swanton, she was also directing inquiries about the Chitimachas' legal status to the Office of Indian Affairs in Washington, D.C. Quickly realizing that federal officials knew very little about the tribe, and perhaps cared even less, she wondered if a local person might be appointed to handle the leasing of Chitimacha land. "As we have no representative in that part of the country," acting commissioner J. Henry Scattergood replied in August 1929, "we shall be glad to take advantage of your kind offer to find some responsible man to look after the rental of their land and attending to such other matters as may arise."[29] But complications arose due to lingering reluctance within the Indian Office and deepening division within the Chitimacha community. Over the next few years, members of the tribe sent complaints to Washington about Benjamin Paul's and Ernest Darden's failure to keep up with rent payments. Both men were trying to raise sugarcane on a portion of tribal land, at the rate of one-fifth crop share promised the tribe, but Emile Stouff and Alex Darden reported that nothing was received for the lease. "Did the office at Washington," Alex Darden asked Commissioner Charles Rhoads in March 1932, "appoint Mr. Ben Paul to rent or have this land worked and don't give us nothing or can we have it worked our self and get the rent or share?" Meanwhile, Chief Paul was also appealing to Rhoads for financial assistance "because we in hard time over here no work can get not thing." The commissioner's reply only echoed what the Chitimachas had been hearing for decades: the Office of Indian Affairs could not use funds to help them since they did not possess the status of "wards of the United States." This position, however, did not prevent the Department of Interior the very next year from approving an oil- and gas-mining lease on Chitimacha land, which actually exacerbated tension within the community over rents and royalties.[30]

Refusal by the Indian Office to treat the Chitimachas as a federally recognized tribe, despite the trust status of their land, also stood in the way of efforts to establish a tribal school. Like many

other Indians in the Jim Crow South, they did not want to enroll in a "colored school" and were not welcome in public schools for whites. As explained by Alice M. Peters, writing to Commissioner Rhoads from nearby Jeanerette, Louisiana, "conditions have made it unfavorable for them to get any type of education in the last ten or twelve years." To underscore how "badly" the Chitimachas' twenty or so school-age children wanted their own school, Peters declared, "it would bring more joy than the finest gift for Christmas." This campaign for opening a federal school for Chitimacha children, which included appeals from State Superintendent of Education T. H. Harris and U.S. senator Huey P. Long, elicited nothing but evasion from the commissioner of Indian Affairs.[31] But the scene in Washington was about to change. With the election of Franklin Delano Roosevelt to the presidency, Indian policy reformers swept into the Office of Indian Affairs under Georgia-born and newly appointed commissioner John Collier. The New Deal for American Indians created new possibilities for the Chitimachas. By 1934 the OIA's director of education, W. Carson Ryan, declared that they were "a definite Indian group living on untaxed Indian land, [and so] the federal government clearly has a responsibility for their education."[32]

Now that the Office of Indian Affairs was more forthrightly acknowledging responsibility for the Chitimachas, Caroline Dormon could lobby on their behalf with greater confidence. John Collier himself replied to one of her letters in September 1935, even reporting that he shared it with John Swanton who "spoke of knowing you, and of your interest in the Louisiana Indians." But when it came to answering Dormon's specific question about availability of funds and personnel, Collier confessed to being uncertain about "what we can undertake for these Louisiana groups." Several staff members, he reported, were "aware in general of their problems, and . . . would like to see a careful study undertaken in preparation for any possible Federal program. If such a study does become possible, we shall, of course, get in touch with you. In the mean time, we are glad to have your material."[33] Obviously the U.S. Office of Indian Affairs had plenty of catching-up to do when it

came to southern Indians like the Chitimacha tribe, so information offered by allies like Caroline Dormon was instrumental. The best that Collier's administration could do right away was to assign Chitimacha affairs to the superintendent of the Choctaw Indian Agency in Philadelphia, Mississippi. From that distance, it should come as no surprise, attention to concerns at Charenton proved to be sporadic at best. Christine Paul sent letters to Dormon as well as to the Indian Office expressing doubt about Archie Hector's reliability, particularly when it came to securing royalties from the oil company drilling on Chitimacha land. "I don't belive in him," she wrote Dormon in January 1936. "Maybe he good man but I don't know. They people full Indians so much it hard to mack me belive in them. They don't do they right work for they Indian. They white people around here they allway keep Indian in dack so its hard to mack me belive in them around here esplsy now my old man is not here. I no he unstoud every thing better then us. Oh Miss Dormon I misse my Dear old Husband."[34]

In contrast with predecessors Mary Bradford and Sara McIlhenny, Caroline Dormon's interest in Indian affairs went beyond assistance to the Chitimacha community. A longtime participant in the Louisiana Federation of Women's Clubs, she accepted appointment as advisory chairman in its Division of Indian Welfare. In August 1937 Caroline Dormon wrote to U.S. senator Allen J. Ellender about a variety of political issues. A fervent follower of FDR, she commended the senator from Louisiana for his position on the Supreme Court bill and condemned other southern Democrats for failing to see how recent legislation favored development in the South. "During the present administration," she opined, "the South was beginning to come out from under the dark cloud which had enveloped it since Reconstruction days." Then turning to Indian affairs, Dormon told Ellender, "Under the splendid guidance of John Collier, these oppressed peoples are taking new hope, and making wonderful strides forward, toward becoming useful and productive citizens." She called previous U.S. treatment of Indians "the blackest stain on American history."[35]

A year later Dormon drafted a brief report, "Indian Welfare," in Louisiana for the state's Federation of Women's Clubs, which like other state federations was then trying to generate greater interest in Indian people among local clubs. Since the time when Mary McIlhenny Bradford began working with Chitimacha basketmakers, women's exchanges and clubs—including many organizations across the South—constituted an important network of support and advocacy for American Indian issues.[36] The national president of the General Federation of Women's Clubs (GFWC) during Caroline Dormon's federation work on behalf of Louisiana Indians was Roberta Campbell Lawson, granddaughter of Delaware Indian chief Charles Journeycake and wife of Oklahoma banker and oilman Edward Campbell Lawson. For three decades Lawson held offices in women's clubs at local, state, and national levels. Possessing a degree in music studies from Hardin College and committed to preserving American Indian songs and hymns, she became music chairman for GFWC. In 1926 Lawson published *Indian Music Programs*, not only a guide for federated women's clubs to use in programing their events but an insight into the role of music in American Indians' histories and daily lives. Another influential figure in 1930s women's club work on behalf of Indian people was Anna Ickes, member of GFWC's Indian Welfare Committee and wife of Secretary of Interior Harold Ickes. As vice-president of the Chicago Women's Club, she had been responsible for Ickes's first meeting with John Collier back in 1923, when as research agent for GFWC Collier had been hosted—along with a delegation of Pueblo leaders—at a luncheon in the Cliff Dwellers Club.[37]

The information that Caroline Dormon provided to the Louisiana Federation of Women's Clubs was meant for inclusion in a verbal report at its upcoming state convention in Baton Rouge. In her summary of the Chitimachas, she made sure to write that they "still retain their ancient art, basket-making, which is not surpassed anywhere in the United States." While noting that all Louisiana Indians "still make the southern cane baskets," she emphasized that "the Chitimacha excel in the art."[38] As a member of

the Daughters of the American Revolution, Dormon was also connected with that national organization's contemporaneous call for Indian work among its members. In December 1937, Mary Frere Caffery—married to a prominent businessman and politician in Franklin, Louisiana—was asked by Daughters of the American Revolution state regent Olivia Lacey to ascertain two things for the upcoming state conference: first, if any "remnants of Indians in the State" lived on a reservation, and second, "whether or not any or all of the children in the little school at Charenton can make the lovely baskets and mats that are made by the older women." For information regarding Louisiana Indians, Caroline Dormon was mentioned by Lacey as a reliable source. Aggressively seeking opportunities to demonstrate organizational support of Indian people, as the Indian New Deal got underway, the Daughters of the American Revolution now wanted to encourage them to make and market handicrafts for economic benefit. Lacey envisioned a photograph appearing in the *New Orleans Times Picayune* that might feature students and baskets at the school house "and in the background one or two DARs as sponsoring this work."[39]

The most important development for the Chitimachas under the Indian New Deal was indeed the establishment of a federally supported school at Charenton. By the start of 1935, the Indian Office's Department of Education had a two-room building moved onto the reservation from a few miles away and had allocated $359 for repairs and equipment.[40] Timing for the start of this tribal school, although a long time overdue, could not have been more conducive for experimenting with arts and crafts in the curriculum. Directors of education for the Indian Office under Collier, first W. Carson Ryan and then Willard W. Beatty, were leaders of progressive educational reform who sought not only to replace boarding schools with day schools but to implement community-oriented and culture-based programs. The hiring of craftspeople to teach their knowledge and skills to schoolchildren thus became a widespread practice across Indian country. So when Edna Groves, superintendent of education at Cherokee, North Carolina, visited Charenton in

December 1937, she could report back to Beatty, "The school at this place is a real center for the community and much good work is being accomplished," even though the building needed improvement and expansion. "Since my previous visit," Groves wrote, "basketry is being taught in the school and it is hoped that the technique be carried on."[41] Sure enough, a month later Christine Paul informed Caroline Dormon that "I am teaching some our little grils mack Baskets at school house. I go every evening two hours every week and they learning nice. They mack some pretty little Baskets." Christine was also busy making her own baskets for an order requested by Dormon, hoping to put together enough money to buy a tombstone for Ben's grave. "I want to put one if I can before I die," she wrote.[42] Teaching basketry in the Chitimacha school resulted largely from initiatives inside and around the community. However, by comparison, the Eastern Band of Cherokee Indians in North Carolina were at this same time influenced directly by the federal government's Indian Arts and Crafts Board, whose staff were providing strong guidance for the instruction of tribal arts and crafts at their tribal school.[43]

Direction of the Chitimacha tribal school came under the very capable supervision of Heloise Faye Delahoussaye, a teacher who graduated from Southwestern Louisiana Institute in Lafayette with a degree in home economics. When the superintendent of the Choctaw Indian Agency visited the school in December 1939, he was pleased with recent repairs and additions on the grounds and found it to be "excellently conducted" and to be making "very encouraging progress" in academics. "The basket weaving under an experienced weaver," he added, "is a part of the school program and is a very evident continuation of an outstanding art in which the Chittimanchi Indian women excel." There was also a plan under way to plant some river cane in the school yard, near a vegetable garden tended by the students, "to provide raw material for the basket weaving." By 1942 Pauline Paul, known in the community as "Tante" Paul, replaced her older sister-in-law as basketmaking teacher at the school; Christine Paul died within four years.[44]

Instruction of a craft such as basket weaving as part of a day

school's curriculum reflected a convergence of significant changes in American society—particularly in perceptions of Indian people and their culture. The 1920s saw mounting criticism of the federal government's assimilationist policy toward Native Americans. Failure to improve their economic condition, despite the aggressive assault waged on their traditional culture over many decades, invited consideration of both means and ends. Growing appreciation for the aesthetic and economic value of American Indian traditions, thanks in large part to the earlier arts and crafts movement, coincided with broader ethical concerns about the impact of assimilationism on Indian life. By 1928, when the Institute of Government Research issued a major report on problems in Indian administration, policy reformers determined that unfortunately "native industries have . . . received little encouragement from government officers and missionary workers. This neglect in some cases springs from contempt for all that constitutes distinctive Indian life. More generally, however, the failure to foster these arts seems to be due to a lack of understanding of their economic possibilities."[45] So when reformers moved into the Office of Indian Affairs under native Georgian John Collier, they immediately began to implement efforts in tribal schools and community centers not only to preserve surviving handicrafts but to promote marketing of them. The epitome of this redirection came in 1935 with Congress's passage of the Indian Arts and Crafts Act, which created a federal bureaucracy that would vigorously advance production and sales.[46]

Meanwhile, the art world became more attentive toward the artistic significance of objects that had long been relegated strictly to the realm of ethnographic artifacts and primitive crafts. Critics and artists alike began to value everything from pre-Columbian carvings and ceramics to contemporary textiles and basketry as imaginatively designed and finely created works of art. Cosmopolitan figures such as Marsden Hartley, John Sloan, and Walter Pach, seeking to advance a unique and independent art tradition for the United States, energized aesthetic appreciation of Indian arts and crafts.[47] In December 1931, the Eastern Association of Indian

Affairs and the New Mexico Association of Indian Affairs launched the Exposition of Indian Tribal Arts in New York City at the Grand Central Art Galleries. It exhibited 650 objects from private collections and museums and traveled to thirteen other cities over the next two years. The time had come for the scientific collection and curio consumption of Indian objects to be displaced by aesthetic appreciation. The exhibit organizers declared that "the Indian is a born artist."[48] In 1932 Christine Paul sent some baskets to John Sloan, the well-known Ashcan school artist who was presiding over the Exposition of Indian Tribal Arts board. It does not appear that any of these Chitimacha baskets actually appeared in the traveling exhibit, but they did end up being bought by Amelia Elizabeth White, who then donated them to Santa Fe's Indian Arts Fund.[49]

Subsequent events also displayed to attendees a new understanding of Indian life and thought—as expressed through arts and crafts as well as dances and ceremonies that had long been subjected to destruction and sentimentality. In 1939 the U.S. government organized an Indian arts exhibit and market at the Golden Gate International Exposition in San Francisco. And two years later, the landmark exhibit *Indian Art of the United States* opened at the Museum of Modern Art in New York City.[50] As Frederic H. Douglas, curator of Indian art at the Denver Art Museum, and Rene d'Harnoncourt, general manager of the Indian Arts and Crafts Board, wrote in the publication accompanying the historic exhibition at New York's MOMA, these cultural achievements carried "values so deeply rooted in tribal life that they are a source of strength for future generations." Traditional forms of art would facilitate American Indians' movement through the modern age, while also enriching non-Indians' appreciation of their creative contributions to the world. However, Douglas, who specialized in Plains Indian art, and d'Harnoncourt, whose expertise was in Mexican folk art, did not abandon altogether a tendency to ethnographically categorize and compare. *Indian Art of the United States* was organized into familiar culture areas, with each area named with some primal occupation—for example, "The Woodsmen of the Eastern Forest," "The Hunters of the Plains," and "The Pueblo

Farmers." Basketry, predictably, was featured only in the chapter on "The Seed Gatherers of the Far West," where this craft purportedly developed further than in any other region. Although Douglas and d'Harnoncourt did acknowledge, in prefatory remarks, "considerable development of basketry in the South and to a lesser extent in the Northeast," they quickly concluded that neither "compares in quantity and quality with western work." For Chitimachas and other American Indians still weaving beautiful baskets in the Southeast, here was a lost opportunity to receive significantly wider attention.[51]

Thanks to appreciation and encouragement provided by allies such as Caroline Dormon, however, Chitimacha basketry did not go unrecognized. When the director of education from the Office of Indian Affairs visited the Chitimacha school in March 1938, he brought some baskets back to Washington, D.C. A couple of months later, Willard Beatty wrote to the school's principal, Heloise Delahoussaye, asking if she might "persuade your Indian women to produce as large a quantity of basketry as possible during the next year" in order to place them on sale at the San Francisco World's Fair. "You will be interested to know," he informed her, "that the few baskets which I brought back with me from Louisiana were snatched out of my office almost before I had had a chance to show them to the staff. I could have sold four or five times as many. While I don't wish to interfere with the building up of a stock for sale at the exposition, I think I can offer to dispose of baskets for you here in Washington about as rapidly as you can send them to me, at least for some time to come."[52]

Although basketry was still being taught in the tribal school, the number of weavers at Charenton had declined to only a few women by the late 1930s, so it is unlikely that Chitimacha baskets ever reached the Golden Gate International Exposition. But in 1945 Caroline Dormon did have success in getting Pauline Paul to make a significant quantity and variety of baskets for the Louisiana State Exhibit Museum in Shreveport.[53] Clarence Webb, a pediatrician with strong interest in archaeology and ethnology, relied heavily on Dormon's close friendship with Paul to acquire what he wanted

for an Indian gallery inside this New Deal public works project. She even loaned baskets from her personal collection for him to exhibit temporarily. Inside each basket she dropped a description written on a slip of paper. "In your statement which you will post above the display," Dormon instructed Webb, "be sure to say that in early days, all Southern Indians used the beautiful native dyes, but now only the Chitimacha keep up the ancient practice."[54]

Pauline Paul's production of baskets for the Louisiana State Exhibit Museum, however, did not occur without a worrisome snag, revealing that transactions in the 1940s could still bring familiar stresses and strains to the relationship between artist and patron. When Dr. Clarence Webb failed to send Pauline a check for her set of baskets in satisfactory time, she wrote a desperate letter to Caroline on New Year's Day 1946, wondering if she would ever get paid by the person Dormon must have earlier called "a fine man." "I am very sorry I had worked so hard to compited the work for Christmas, and do not know whom to pay me. Please le me know whom you trust to pay me the $20.80." Within only a few days, a distressed Caroline Dormon sent a plea to Webb along with Pauline Paul's letter. "I know this will wring your heart, too, as the poor things are so pitifully poor—I did want them to get the money for Christmas. Of course I simply *forgot* that it was for a state institution, and that the bill would have to go through the mill to be okayed, etc." Dormon asked Webb to advance money to Paul. "Meanwhile, I am writing to explain the situation to Pauline, and to reassure her that you *are* a 'fine man!'" Webb had already asked for a duplicate set of the "quite beautiful" baskets for his own collection, so Dormon added, "I will also make it clear to her that you want exactly the same baskets for yourself. Owing to this hitch, she may not have started yours—but I hope she has."[55]

Caroline Dormon's relationship with Christine Paul and her sister-in-law Pauline Paul was personal rather than professional, much like Mary Bradford's earlier relationship with them. And in Dormon's case as well, working on behalf of Chitimacha basket-makers did not become a full-time passion or commitment for

her. Dormon was most prominently a conservationist and naturalist, her interest in American Indians deriving in large part from her deep love of the surrounding natural world. But although a self-taught and self-employed social scientist, she nonetheless resembled other American women who in the 1930s and 1940s contributed significantly to conjoining applied anthropology with government service. "The scope of women's role in shaping and executing the New Deal," as Sara M. Evans put it, "has long been overlooked." And despite their low profile as a movement, such women "represented the culmination of more than a century of organized activity on the part of ordinary women."[56] Caroline Dormon personified this important feature, in a sense extending the legacy of Mary Bradford and Sara McIlhenny across the mid-twentieth century. The Indian Arts and Crafts Board, which of course did not exist before the New Deal, provided a special opportunity for several women anthropologists whose assignment as specialists in Indian Arts and Crafts paralleled Dormon's unofficial work. For an annual salary of about two thousand dollars, Gwyneth Browne Harrington (daughter of an insurance company executive in Boston), Gladys Tantaquidgeon (Mogehan Indian protégé of University of Pennsylvania anthropologist Frank Speck), and Alice Marriott (first woman to earn a BA in anthropology at the University of Oklahoma) were employed directly by the board to advance craft production and marketing. All three women worked closely with basketmakers at some stage in their careers. Marriot is best known for her relationship with Maria Martinez, authoring a widely appreciated biography of this famous Pueblo potter, but she also studied and promoted basketry made by Choctaw and Cherokee weavers in Oklahoma.[57]

Caroline Dormon aspired to see more of her own ethnographic work appear in published form, but the results were disappointing for her. Over many years she tried to find a publisher for several stories that she had written for young readers. In this pursuit, she wrote to an editor at the David McKay Company in 1943, explaining why and how she "filled notebooks with this lore, before the Old Ones passed on." Having taught children earlier in her career

and knowing what they like to read, Dormon wanted "them, and grown-ups, too, to become acquainted with our gentle and fascinating Southern Indians. I may add that I also speak the language of the wild things—which is necessary when writing of aboriginal Americans."[58] Not until 1967, only four years before her death, was the book *Southern Indian Boy* eventually published by Claitor's Book Store of Baton Rouge. One of the two stories contained therein was "Red Boots and Deer Runner"—about a fictional friendship between a Chitimacha boy and a French boy during the colonial period.[59] "Few of us who read and enjoy Caroline Dormon's books about plants realize," William Lanier Hunt wrote in his review of *Southern Indian Boy*, "that she is one of the South's few experts on the Indians, too." When Hunt last visited Dormon at Briarwood, she showed him some of her Indian baskets and explained their designs to him. "A lifetime of study and visits with her Indian friends," he concluded, made "Caroline Dormon the Southerner who knows most about our Southern Indians."[60]

It should be clear by now that all three Southerners featured in these chapters knew a lot about southern Indians—Christine Paul obviously because she lived the life of a southern Indian, Mary Bradford and Caroline Dormon largely because of relations formed with this southern Indian woman. If exquisite baskets produced by Chitimacha women were responsible for drawing Bradford's and Dormon's attention toward their community, the circulation of those baskets away from Charenton, Louisiana, extended their personal relationships into a widespread network of exchange and an effective instrument of change. The motives and interests behind each woman's participation varied significantly—sometimes even causing stressful apprehension and miscomprehension. Mary Bradford, in many ways representing her status as a socially responsible woman in late Victorian times, saw her deeds on behalf of Chitimacha people as a philanthropic business—putting her own abilities to the test while challenging boundaries imposed by others. Caroline Dormon, an educated middle-class woman entering adulthood during the Progressive Era, saw her work for them as more scientific—connecting naturally with her other research

fields and public projects. And weaving together the works of both white women, across time and space, was Christine Paul, an Indian woman with fewer advantages and resources than either ally but with extraordinary skills in basketry and communication. Her persistent deployment of these skills on behalf of family and community, through enduring relationships with Mary Bradford, her sister Sara McIlhenny, and Caroline Dormon, contributed immeasurably to the survival of the Chitimacha people and consequently to the ongoing story of American Indians in the South.

"What a Chitimacha Indian Woman Did for Her People,"
by Mary Avery McIlhenny Bradford,
a twelve-page handwritten manuscript in the
McIlhenny Company and Avery Island, Inc.,
Archives, dated June 26 [no year]

At Charenton, La. on July 10th 1910 died Clara Darden, a Chitimacha Indian woman, 100 years old. Her people had been famed in times past for their beautiful basketry, which owing partly to lack of education (the white people of the adjacent town refusing to allow the Indian children to enter their schools & the Indians too self respecting to send their children to the colored schools) & there being no one among them who could by writing find a market for their baskets they had gradually ceased making them as the young girls no longer learned to make them, until then Ish-pouch-prinichon-kal-ta (Indian friend) Ca mu-mê' stin (white flower) promised that if old Clara Darden would teach the young girls & women what cane to gather, how to cure & split them with their teeth, what roots to gather, how to make with them their rich red, yellow & black dyes, to dye the canes & then to weave the baskets both single and double weave, with their many different & beautiful designs, that she would then ship & sell all the baskets they could make. And Tante Clara became fired with the love of her youth for her beautiful basketry she had been so famed for,—and though so very very old with but one tooth (they split the cane with their teeth) and one eye, she taught the girls untiringly and unceasingly until their baskets grew to perfection, an immemorial record of her love for her people. Ca mu-mê' stin giving a prize for

every perfect basket the girls made. Until Tante Clara's mind nearing a century in age, became clouded at times, and the little story that follows is of that period.

[The rest of this page is blank, and the next page begins with "Conclusion." Apparently this is where the story would be placed. A separate document in the archives, eight typed and double-spaced pages titled "A Little Story of a Basket," is probably what Mary intended to go here to make a single work.]

Conclusion

My object in writing this little story of this old, *very poor*, very illiterate Indian woman, Tante Clara, is to appeal to you, of position, education, and possibly wealth, to assist me by small contributions to put up a head stone, very simple & commemorative of this old woman for her people not only because I feel it due her but that those who follow after seeing her so honored may find in it a stepping stone to raise them up to nobler deeds.

Contributions to be sent (P.O. order preferred) to Mrs. Sidney Bradford, Avery Island, La.

Photographs of Tante Clara at work on her baskets can be had @.50 at this same address also the baskets sold here. For more information regarding the Chitimacha Indians and plates of the baskets, see Bulletin 43 of Bureau of American Ethnology, Indian Tribes of the Lower Miss. Valley and Adjacent Coast of the Gulf of Mexico by John R. Swanton.

Mrs. Sidney Bradford, Avery Island, La., June 26th

A Little Story of a Basket.

Christine Paul, the wife of the Chief Ben Paul, when a small child, was placed in a convent where, for the work she did, she was taught to read and write a little. Her mite of learning she has made to serve for her whole people, who are without education.

Standing with her husband at the head of her tribe, with no children of her own, she mothers all the orphan children, for they are brought to her to raise; she nurses the sick; she marks, measures, puts up, and ships the baskets for them all, and receives and distributes the money for them, and does so many little things for her people that one can not tell them all.

This is *one of the little things*.

Christine was seated at my feet on the steps of the gallery of their house, on the bank of the Bayou Teche, which is among the grand old live oaks near a little reedy spot that was blue with flags. "That's just to grow 'Poor-Asche' (one of the roots with which they make the dyes) for us, so we wont have to go far to pick it" Christine had told me once.

"Oh you better not steal from us, you red wing," she exclaimed as some red winged black birds flew from the reedy spot over her garden. "You know we made for you those pretty wings. You know, Ca mu-mê' stin, its Tante Clara who tells us all those stories you like to hear. I going to tell you that one how the black bird got its red wing next time." She leaned back looking beyond me into the house. "Excuse me, Ca mu-mê' stin, just a minute"—and with the quick, noiseless movement of her race, she slipped into the house: I, looking after her, saw her go to where an old, old, Indian woman, Tante Clara, who had been at work on a basket, had fallen asleep in her chair, all bent over her work. Christine, placing a pillow from the bed in the back of the chair, tenderly lifted the old woman against it, then, taking the unfinished basket from her lap and a little bowl of water from the chair next to her, she came back to me, holding the basket out for me to look at, saying "I know you not going to tell, Ca mu-mê' stin, so I going to tell you"—when she saw the amazement in my face, for from the hands of old Clara Darden, famed for her exquisite basket work, Christine had taken the basket, and the pattern had run all astray, the beauty and symmetry gone. "Why—Christine" I exclaimed "how could old Clara have made this"—, "Oh, Ca mu-mê' stin, you know what Tante Clara could do with her baskets, you know how fine she make them, you

know how she taught us all how to make baskets, but now, poor Tante Clara, she so old, she not able to split cane any more, she cant get the roots and make dye, so, when I get ready to make baskets, I fix plenty of canes, I dye plenty, and I take some and put on chair by Tante Clara, because she love to make her baskets, but she so old." She thought for a minute looking out over her garden.

"Look, Ca mu-mê' stin, you see those little butterflies out there. See how they fly up so high, they gone, but look, you see they come back again. Now they fly little way. Now they come back. See, now they fly so high, it take long time to come back. Its that way with Tante Clara. She love to work her basket, she find the cane there, she take some, she begin, and she make it *so* fine, *so* pretty, and then her mind, it gone."

She made the motion of the butterflies with her hands.

"And when it gone, she make it all crooked, like this. But her mind, it gone, so she don't know she make it crooked."

All the time she was speaking, her busy fingers were picking out the crooked pattern.

"So when she go to sleep, I take it, and I pick it *all* out she make crooked."

She looked at me, her eyes shining with tenderness.

"And then, I make that much all straight again, and I put on chair where she left it.

Now, when she wake up, you going to see. Her mind, it all right. She pick up her basket. Its all pretty, she work some more on it, it all straight, what she make now. And she never know she make it crooked.

I never tell. And, I know you wont tell, Ca mu-mê' stin.

Preface

1. Notebooks, Folder 1488, Caroline Dormon Collection, Cammie G. Henry Research Center, Watson Library, Northwestern State University of Louisiana, Natchitoches.

2. Clara Sue Kidwell, "Indian Women as Cultural Mediators," *Ethnohistory* 39 (Spring 1992): 97–107, quote from 98.

3. Lucy Eldersveld Murphy, "Public Mothers: Native American and Métis Women as Creole Mediators in the Nineteenth-Century Midwest," *Journal of Women's History* 14 (Winter 2003): 142–66; Murphy, "Women, Networks, and Colonization in Nineteenth-Century Wisconsin," in *Contours of a People: Metis Family, Mobility, and History,* ed. Nicole St-Onge, Carolyn Podruchny, and Brenda Macdougall (Norman: University of Oklahoma Press, 2012), 230–64.

4. Devon Abbott Mihesuah, *Indigenous American Women: Decolonization, Empowerment, Activism* (Lincoln: University of Nebraska Press, 2003), 4; Rebecca Sharpless, "Neither Friends nor Peers: Idella Parker, Marjorie Kinnan Rawlings, and the Limits of Gender Solidarity at Cross Creek," *Journal of Southern History* 78 (May 2012): 327–60.

5. Nick Salvatore, "Biography and Social History: An Intimate Relationship," *Labour History* 87 (November 2004): 187–92, quote from 190; Rebecca Solnit, *The Faraway Nearby* (New York: Viking, 2013), 194. Also see insightful essays in the "AHR Roundtable: Historians and Biography," *American Historical Review* 114 (June 2009): 573–661.

6. I have dealt with this dynamic in regard to economic behavior and discourse in Daniel H. Usner Jr., *Indian Work: Language and Livelihood in Native American History* (Cambridge, Mass.: Harvard University Press, 2009).

7. The contributions referred to here includes this sample, in chronological order of publication: Harry A. Kersey Jr., *Pelts, Plumes, and Hides: White Traders among the Seminole Indians, 1870–1930* (Gainesville: University Press of Florida, 1975); James H. Merrell, *The Indians' New World: Catawbas and*

Their Neighbors from European Contact through the Era of Removal (Chapel Hill: University of North Carolina Press, 1989); Stephen R. Potter, *Commoners, Tribute and Chiefs: The Development of Algonquian Culture in the Potomac Valley* (Charlottesville: University Press of Virginia, 1993); Kathryn E. Holland Braund, *Deerskins and Duffels: Creek Indian Trade with Anglo-America, 1685– 1815* (Lincoln: University of Nebraska Press, 1993); Sarah H. Hill, *Weaving New Worlds: Southeastern Cherokee Women and their Basketry* (Chapel Hill: University of North Carolina Press, 1997); Daniel H. Usner Jr., *American Indians in the Lower Mississippi Valley: Social and Economic Histories* (Lincoln: University of Nebraska Press, 1998); Patsy West, *The Enduring Seminoles: From Alligator Wrestling to Ecotourism* (Gainesville: University Press of Florida, 1998); Thomas John Blumer, *Catawba Indian Pottery: The Survival of a Folk Tradition* (Tuscaloosa: University of Alabama Press, 2004); Paul Kelton, *Epidemics and Enslavement: Biological Catastrophe in the Native Southeast, 1492–1715* (Lincoln: University of Nebraska Press, 2007); David La Vere, *Looting Spiro Mounds: An American King Tut's Tomb* (Norman: University of Oklahoma Press, 2007); Cameron B. Wesson, *Households and Hegemony: Early Creek Prestige Goods, Symbolic Capital, and Social Power* (Lincoln: University of Nebraska Press, 2008); Joseph M. Hall Jr., *Zamuno's Gifts: Indian-European Exchange in the Colonial Southeast* (Philadelphia: University of Pennsylvania Press, 2009); Shepard Krech III, *Spirits of the Air: Birds and American Indians in the South* (Athens: University of Georgia Press, 2009); Robbie Ethridge, *From Chicaza to Chickasaw: The European Invasion and the Transformation of the Mississippian Worlds, 1540–1715* (Chapel Hill: University of North Carolina Press, 2010); Sophie White, *Wild Frenchmen and Frenchified Indians: Material Culture and Race in Colonial Louisiana* (Philadelphia: University of Pennsylvania Press, 2012); Andrea Feeser, *Red, White, and Black Make Blue: Indigo in the Fabric of Colonial South Carolina Life* (Athens: University of Georgia Press, 2013).

8. Daniel Miller, "Introduction," in *Materiality*, ed. Daniel Miller (Durham, N.C.: Duke University Press, 2005), 32; Webb Kane, "Signs Are Not the Garb of Meaning: On the Social Analysis of Material Things," in Miller, *Materiality*, 184–90.

9. Jolene Rickard, "Visualizing Sovereignty in the Time of Biometric Sensors," *South Atlantic Quarterly* 110 (Spring 2011): 465–82.

10. Mindy J. Morgan, *The Bearer of This Letter: Language Ideologies, Literacy Practices, and the Fort Belknap Indian Community* (Lincoln: University of Nebraska Press, 2009).

11. For insight into comparative "feats of writing," see Karin Barber, ed.,

Africa's Hidden Histories: Everyday Literacy and Making the Self (Bloomington: Indiana University Press, 2006), especially the editor's introduction. Also see Leora Auslander, Amy Bentley, Leor Halevi, H. Otto Siburn, and Christopher Witmore, "AHR Conversation: Historians and the Study of Material Culture," *American Historical Review* 114 (December 2009): 1355–1404.

Chapter One. *"Entirely a Philanthropic Work"*

1. Mary Bradford to Christine Paul, July 4 [1902], Chitimacha Papers, McIlhenny Company and Avery Island, Inc., Archives, Avery Island, La.

2. For background history of Indian basket marketing in the lower Mississippi Valley, see Usner, *Indian Work*, 93–116.

3. Sarah H. Hill, *Weaving New Worlds: Southeastern Cherokee Women and Their Basketry* (Chapel Hill: University of North Carolina Press, 1997).

4. Albert Gatschet, "The Shetimasha Indians of St. Mary's Parish, Southern Louisiana," *Transactions of the Anthropological Society of Washington* 2 (February 7, 1882–May 15, 1883), 148–59.

5. *Historical Sketch Book and Guide to New Orleans, Edited and Compiled by Several Leading Writers of the New Orleans Press* (New York: Will H. Coleman, 1885), 169–70; World's Industrial and Cotton Centennial Exposition, Department of Louisiana [Report of Commissioner C. J. Barrow to Governor S. D. McEnery] (New Orleans: Department of Louisiana, World's Industrial and Cotton Centennial Exposition, 1885), 21; "World's Industrial and Cotton Centennial Exposition," *New Orleans Times-Democrat*, April 6, 1885.

6. Charles Dudley Warner, *Studies in the South and West with Comments on Canada*, in *The Complete Writings of Charles Dudley Warner*, vol. 8, ed. Thomas R. Lounsbury (Hartford, Conn.: American Publishing, 1904), 90; Alcée Fortier, *Louisiana Studies: Literature, Customs and Dialects, History and Education* (New Orleans: F. F. Hansell, 1894), 165; Grace King, *New Orleans: The Place and the People* (New York: Macmillan, 1895), 75.

7. Shane K. Bernard, *Tabasco: An Illustrated History, the Story of the McIlhenny Family of Avery Island* (Avery Island: McIlhenny Company, 2007), 26–33, 58, 83, 99, 119, 141; correspondence from Shane Bernard (historian and curator of the McIlhenny Company Archives), June 30, 2014.

8. Charles Dudley Warner "The Acadian Land," *Harper's Monthly Magazine* 74 (February 1887), 94–95.

9. "St. John Champions: The Eighteenth Annual Regatta of the St. John

Rowing Club," *New Orleans Daily Picayune*, May 25, 1890; "Society," *New Orleans Daily Picayune*, September 29, 1895; "Football: The Great Game with Nashville," *New Orleans Daily Picayune*, December 31, 1896; Stuart O. Landry, *History of the Boston Club* (New Orleans: Pelican, 1938), 148–51, 212, 222, 281; correspondence from Gray Osborn (a great nephew of Mary Bradford) on March 19, 21, 22 and 28, 2011, and conversation at his home on June 5, 2012.

10. Chief John Paul to Mary Bradford, June 21, 1899, and Diary of Mary Bradford, June 23, 1899, Mary Bradford Papers, McIlhenny Company and Avery Island, Inc., Archives, Avery Island, La.

11. Christine Paul to Mary Bradford, September 10, 1899, Mary Bradford Papers. For a contemporaneous description of Grand Lake, including a levee built to protect plantation fields from its springtime overflow, see Fortier, *Louisiana Studies*, 166–67.

12. Christine Paul to Mary Bradford, May 13, 1904, Mary Bradford Papers. My description of Chitimacha basketry is also drawn from John R. Swanton, *Indian Tribes of the Lower Mississippi Valley and Adjacent Coast of the Gulf of Mexico* (Washington, D.C.: Government Printing Office, 1911), 347–48; Caroline Dormon, "The Last of the Cane Basket Makers," *Holland's, the Magazine of the South*, October 1931, 13, 66; Hiram F. Gregory and Clarence H. Webb, "Chitimacha Basketry," *Louisiana Archeology* 2 (1975): 28–33; and John Paul Darden, Scarlett Darden, and Melissa Darden Brown, "In the Family Tradition: A Conversation with Three Chitimacha Basketmakers," in *The Work of Tribal Hands: Southeastern Indian Split Cane Basketry*, ed. Dayna Bowker Lee and H. F. Gregory (Natchitoches, La.: Northwestern State University Press), 29–41.

13. To learn how patronage of Cherokee basketry fit into the wider context of craft revivalism in Southern Appalachia, see Sarah H. Hill, "Marketing Traditions: Cherokee Basketry and Tourist Economies," in *Selling the Indian: Commercializing and Appropriating American Indian Cultures*, ed. Carter Jones Meyer and Diana Royer (Tucson: University of Arizona Press, 2001), 212–35. Also see Jane S. Becker, "Revealing Traditions: The Politics of Culture and Community in America, 1888–1988," in *Folk Roots, New Roots: Folklore in American Life*, ed. Becker and Barbara Franco (Lexington, Mass.: Museum of Our National Heritage, 1988), 19–60.

14. Max West, "The Revival of Handicrafts in America," Department of Commerce and Labor, *Bulletin of the Bureau of Labor, no. 55, November 1904* (Washington, D.C.: Government Printing Office, 1904), 1574–76.

15. *The Fifteenth Annual Report of the American Museum of Natural History*,

March 1884 (New York: American Museum of Natural History, 1884), 25; Otis Tufton Mason, *Aboriginal American Basketry: Studies in a Textile Art without Machinery*, Annual Report of the Board of Regents of the Smithsonian Institution Showing the Operations, Expenditures, and Condition of the Institution for the Year Ending June 30, 1902, Report of the U.S. National Museum (Washington, D.C.: Government Printing Office, 1904), 388. Also see plates 132, 135.

16. Mrs. Ida M. Dyson to Sarah Avery Leeds, November 23, 1898, Mary Bradford Papers.

17. Philip Deloria, *Playing Indian* (New Haven: Yale University Press, 1998), 103–6; Tom Holm, *The Great Confusion in Indian Affairs: Native Americans and Whites in the Progressive Era* (Austin: University of Texas Press, 2005), xiii. For an important study that situates this period's infatuation with Indian cultural objects in the fullest context of American history—from art history to cultural politics—see Elizabeth Hutchinson, *The Indian Craze: Primitivism, Modernism, and Transculturation in American Art, 1890–1915* (Durham, N.C.: Duke University Press, 2009). An insightful exploration into how support of particular native traditions, in this case among Aboriginal Australians, served non-Indigenous more than Indigenous interests can be found in Elizabeth A. Povinelli, *The Cunning of Recognition: Indigenous Alterities and the Making of Australian Multiculturalism* (Durham, N.C.: Duke University Press, 2002), 35–69.

18. Molly H. Mullin, *Culture in the Marketplace: Gender, Art, and Value in the American Southwest* (Durham, N.C.: Duke University Press, 2001), 37. Also see Ira Jacknis, "Patrons, Potters, and Painters: Phoebe Hearst's Collections from the American Southwest," in *Collecting Native America, 1870–1960*, ed. Shepard Krech III and Barbara A. Hall (Washington, D.C.: Smithsonian Institution Press, 1999), 139–71; Susan Labry Meyn, *More Than Curiosities: A Grassroots History of the Indian Arts and Crafts Board and Its Precursors, 1920–1942* (Lanham, Md.: Lexington, 2001); and Dwight P. Lanmon, Lorraine Welling Lanmon, and Dominique Coulet du Gard, *Josephine Foard and the Glazed Pottery of Laguna Pueblo* (Albuquerque: University of New Mexico Press, 2007). For a sample of scholarship focusing on basketry, see Melanie Herzog, "Aesthetics and Meanings: The Arts and Crafts Movement and the Revival of American Indian Basketry," in *The Substance of Style: Perspectives on the American Arts and Crafts Movement*, ed. Bert Denker (Winterthur, Del.: Henry Francis du Pont Winterthur Museum, 1996), 69–92; Marvin Cohodas, *Basket Weavers for the California Curio Trade: Elizabeth and Louise Hickox* (Tucson: University of

Arizona Press, 1997); Hill, *Weaving New Worlds*; William A. Turnbaugh and Sarah Peabody Turnbaugh, comp. and eds., *Basket Tales of the Grandmothers: American Indian Baskets in Myth and Legend* (Peace Dale, R.I.: Thornbrook, 1999), 21–24.

19. Clara Darden and Christine Paul to Mary Bradford, September 18, 1899, Mary Bradford Papers.

20. Mrs. F. N. Doubleday to Mary Bradford, September 18, 1900, Mary Bradford Papers. For a brief biography of Doubleday (1865–1918), see Gloria Shearin, "Neltje Blanchan (Neltje Blanchan Doubleday)," in *Early American Nature Writers: A Biographical Encyclopedia* (Westport, Conn.: Greenwood, 2008), 62–69.

21. Charles L. "Pie" Dufour, *Women Who Cared: The 100 Years of the Christian Woman's Exchange* (New Orleans: Christian Woman's Exchange, 1980), quotation from the organization's platform, 7.

22. Inventory, 1892–1894, vol. D, Christian Woman's Exchange Records, Louisiana Research Collection, Howard-Tilton Memorial Library, Tulane University, New Orleans, La.; "Her Place at the World's Fair," *New Orleans Daily Picayune*, June 4, 1893; "The Wonders of the World's Fair," *New Orleans Daily Picayune*, June 23, 1893; Eliza Ruhamah Scidmore, "Indian Baskets," *Harper's Bazaar* 27 (September 1, 1894), 704–6; Georgia M. Bartlette to Mrs. W. P. Flower, September 30, 1925, Folder 5, Box 1, Christian Woman's Exchange Records.

23. Erik Trump, "'The Idea of Help': White Women Reformers and the Commercialization of Native American Women's Arts," in Meyer and Royer, *Selling the Indian*, 159–89.

24. Mrs. F. N. Doubleday, *Two Ways to Help the Indians* (Philadelphia: Women's National Indian Association, n.d.), copy in Mary Bradford Papers (quotations from 1, 4, 4–5, 11, 14–15, 16); *Annual Report of the Women's National Indian Association, December, 1900* (Philadelphia: Women's National Indian Association, n.d.), 18, copy in New York Public Library.

25. "The Care of the Red Men: Meeting of the Women's National Indian Association," *New York Times*, December 8, 1892; "Indians and Missionaries," *New Orleans Daily-Picayune*, December 7, 1897, 3; "Woman's Indian Association," *New Orleans Daily-Picayune*, November 9, 1902, 15. For a valuable overview of the WNIA, see Valerie Sherer Mathes, "Nineteenth-Century Women and Reform: The Women's National Indian Association," *American Indian Quarterly* 14 (Winter 1990): 1–18.

26. *Annual Report of the Women's National Indian Association, December, 1902*

(Philadelphia: Women's National Indian Association, n.d.), 28–29; *Annual Report of the National Indian Association, December, 1908* (New York: Women's National Indian Association, n.d.), 19.

27. Mrs. E. J. Ellis to Mary Bradford, March 18, 1902, Mary Bradford Papers.

28. Mrs. F. N. Doubleday to Mary Bradford, November 30, 1901, Mary Bradford Papers; Mrs. F. N. Doubleday to Chief John Paul, December 12, 1901, Chitimacha Papers.

29. Ledger sheet, November 16, 1901–December 14, 1904, Christine Paul to Mary Bradford, December 1, 1901, Mary Bradford Papers.

30. Mrs. F. N. Doubleday to Christine Paul, December 12, 1901, Chitimacha Papers.

31. Mary Bradford to Christine Paul, December 19, 1901, Chitimacha Papers. More is said about that terrible event in chapter 2.

32. Christine Paul to Mary Bradford, August 28, 1902, Mary Bradford Papers; Mary Bradford to Christine Paul, September 2, 1902, Chitimacha Papers.

33. For recent studies of this contested ground in the Southwest, see Flannery Burke, *From Greenwich Village to Taos: Primitivism and Place at Mabel Dodge Luhan's* (Lawrence: University of Kansas Press, 2008); Erika Marie Bsumek, *Indian-Made: Navajo Culture in the Marketplace, 1868–1940* (Lawrence: University of Kansas Press, 2008); and Teresa J. Wilkins, *Patterns of Exchange: Navajo Weavers and Traders* (Norman: University of Oklahoma Press, 2008).

34. The events and activities summarized in this paragraph were gleaned from excerpts in the Diary of Mary Bradford, Bradford Papers; articles featuring Alice Roosevelt's visit to New Orleans and Avery Island in *New York Times*, February 1, 18, 19, 27, March 4, 1903; Alice Roosevelt Longworth, *Crowded Hours: Reminiscences of Alice Roosevelt Longworth* (New York: Charles Scribner's, 1933), 55–56; Landry, *History of the Boston Club*, 163–65; Lucy Matthews Chambers Autobiography, electronic version accessed on March 26, 2013, Matthews-Chambers Papers, State Historical Society of Missouri Research Center, University of Missouri at St. Louis; Bernard, *Tabasco*, 65, 79, 112–19; "Miscellaneous Manufacturing Plants," *Daily Bulletin of the Manufacturers' Record*, October 14 and 22, 1907.

35. Otis Mason to Mary Bradford, April 20, 1903, Mary Bradford Papers; Otis Mason to Grace Nicholson, July 1, 1902, Box 5, Grace Nicholson Papers, Huntington Library, San Marino, Calif.; Mason, *Aboriginal American Basketry*, 388.

36. David W. Noble, *The Progressive Mind, 1890–1917* (Chicago: Rand Mc-Nally, 1970), 44–64; Michael Kammen, *Mystic Chords of Memory: The Transformation of Tradition in American Culture* (New York: Alfred A. Knopf, 1991), 254–82; T. J. Jackson Lears, *No Place of Grace: Antimodernism and the Transformation of American Culture, 1880–1920* (Chicago: University of Chicago Press, 1994), 60–96; Maurice Hamington, *The Social Philosophy of Jane Addams* (Urbana: University of Illinois Press, 2009), 159–61; Daniel E. Bender, *American Abyss: Savagery and Civilization in the Age of Industry* (Ithaca, N.Y.: Cornell University Press, 2009), 23–24, 116–19.

37. Otis Tufton Mason, *Woman's Share in Primitive Culture* (New York: Appleton, 1900), 5, 44, 52.

38. Christine Paul to Mary Bradford, May 2, 1907, John Swanton to Mary Bradford, May 17, 1907, Bradford Papers; Mary Bradford to Christine Paul, n.d. [May 1907], Chitimacha Papers.

39. Neil M. Judd, *The Bureau of American Ethnology: A Partial History* (Norman: University of Oklahoma Press, 1967), 42–43.

40. John R. Swanton, "Proceedings of the Anthropological Society of Washington," *American Anthropologist*, n.s., 11 (July–September 1909): 487; Swanton, *Indian Tribes of the Lower Mississippi Valley and Adjacent Coast of the Gulf of Mexico* (Washington, D.C., 1911), 347–48 and plate 22.

41. M. Raymond Harrington, "Among Louisiana Indians," *The Southern Workman* 37 (December 1908): 656–61. George Gustav Heye, Harrington's employer at the time, would over ensuing decades amass tens of thousands of American Indian objects. With his father's oil-industry fortune and an engineering degree from Columbia, Heye was supervising railroad construction in Arizona in 1897 when he bought a leather shirt from one of the Navajo workers. With this purchase Heye began a private collection that would soon become the Museum of the American Indian in New York City and eventually be held in the Smithsonian's National Museum of the American Indian. Clara Sue Kidwell, "Every Last Dishcloth: The Prodigious Collecting of George Gustav Heye," in Krech and Hail, *Collecting Native America, 1870–1960* (Washington, D.C.: Smithsonian Institution Press, 1999), 232–58; Edmund Carpenter, *Two Essays: Chief and Greed* (North Andover, Mass.: Persimmon, 2005), 15–18, 67.

42. Thomas Sloo to Catherine Gardiner, August 27, 1904, Catherine Marshall Gardiner Papers, Lauren Rogers Museum of Art, Laurel, Miss.; Catherine Gardiner, note written on stationary of Cunard White Star World Cruise, on board the "Franconia," n.d., Gardiner Papers. Also see Jill R. Chancey, ed.,

By Native Hands: Woven Treasures from the Lauren Rogers Museum of Art (Laurel, Miss.: Lauren Rogers Museum of Art, 2005).

43. This is not meant to suggest that the relationship between commercial dealers and Indian producers was a simple one. See Daniel Usner, "An Ethnohistory of Things: Or, How to Treat California's Canastromania," *Ethnohistory* 59 (Summer 2012): 441–63.

44. Catherine Hunter to Grace Nicholson, June 17, September 15, November 21, 1910, Box 9, Grace Nicholson Papers; Grace Nicholson to Mrs. Russell Sage, October 14, 1910, Box 7, Grace Nicholson Papers; Vic Calver, "Sanctuary for Birds Preserving Millions," *New Orleans Times-Picayune*, May 16, 1920; Bernard, *Tabasco*, 132–33; Alice Cooney Frelinghuysen, "Emily Johnston de Forest," *The Magazine Antiques* 157 (January 2000): 192–96. Other wealthy collectors of American Indian baskets during this period included Mrs. Phoebe A. Hearst (gold, silver, and copper mining), Mr. and Mrs. Cornelius Earl Rumsey (NABISCO and Alta Cresta Groves), Mr. and Mrs. Ramsom Eli Olds (Olds Motor Vehicle Company), Edward and Mary Louise Curtis Bok (*Ladies Home Journal*), and Louis Comfort Tiffany (Tiffany and Company).

45. Daniel H. Usner, "From Bayou Teche to Fifth Avenue: Crafting a New Market for Chitimacha Indian Baskets," *Journal of Southern History* 79 (May 2013): 345–46; Rosan Augusta Jordan and Frank de Caro, *Folklore Recycled: Old Traditions in New Contexts* (Jackson: University Press of Mississippi, 2013), 51–83; Greg Olson, *Voodoo Priests, Noble Savages, and Ozark Gypsies: The Life of Folklorist Mary Alicia Owen* (Columbia: University of Missouri Press, 2012).

46. Sara M. Evans, *Born for Liberty: A History of Women in America*, 2nd ed. (New York: Simon and Schuster, 1997), 150; Jackson Lears, "The Managerial Revitalization of the Rich," in *Ruling America: A History of Wealth and Power in a Democracy*, ed. Steve Fraser and Gary Gerstle (Cambridge, Mass.: Harvard University Press, 2005), 181–214.

47. Bernard, *Tabasco*, 68–76, 84. The "civilized masculinity" of John McIlhenny and his brother Edward McIlhenny, particularly in relationship to how they operated the family business, is discussed in Charity Michelle Boutte, "Life, Land, and Labor on Avery Island in the 1920s and 1930s," MA thesis, University of Texas at Austin, 2011.

48. This focus on the needs and aspirations of one Indian group near her home resembled Minnie Moore-Willson's contemporaneous advocacy for the Seminoles from her home in Kissimmee, Florida. Minnie Moore-Willson, "The Seminoles of Florida and Their Rights in the Everglades," *The Red Man* 7 (January 1915): 156–62; Harry A. Kersey Jr., "Those Left Behind: The Seminole

Indians of Florida," in *Southeastern Indians since the Removal Era*, ed. Walter L. Williams (Athens: University of Georgia Press, 1979), 182.

49. Mary Bradford to S. M. McCowan, August 28, 1903, Box 1, Chilocco Indian School Fairs, Indian Archives Collection (Oklahoma Historical Society Research Center, Oklahoma City). Bradford's work toward featuring Chitimacha basketry at the Louisiana Purchase Exposition in St. Louis is detailed in Usner, "From Bayou Teche to Fifth Avenue," 339–74.

50. Mary Bradford to Christine Paul, December 15, 1924, Sara McIlhenny to Christine Paul, April 21, 1926, Chitimacha Papers.

51. John Swanton to Mary Bradford, April 28, 1932, Clark Wissler to Mary Bradford, May 10, 1932, Donald Scott to Mary Bradford, June 15, August 2, 1932, Bradford Papers. The set of eleven baskets purchased from Bradford by the Peabody Museum in 1932 has been studied in Betty J. Duggan, "Revisiting Peabody Museum Collections and Chitimacha Basketry Revival," *Symbols* (Spring 2000): 18–22; Ivan Gaskell, "Ethical Judgments in Museums," in *Art and Ethical Criticism*, ed. Garry L. Hagberg (Malden, Mass.: Blackwell, 2008), 229–42; and Gaskell, "Clara Darden: Brief Life of an Overlooked Artist, c. 1829–1910," *Harvard Magazine* (July–August 2010): 30–31.

52. Mary Bradford to Christine Paul, August 19, 1932, Chitimacha Papers.

53. Mary Bradford to Donald Scott, July 24, 1934, Accession File 32-18-10/30, 32, Peabody Museum of Archaeology and Ethnology, Harvard University, Cambridge, Mass.; Mary Avery McIlhenny Bradford, "What a Chitimacha Indian Woman Did for Her People," a twelve-page handwritten manuscript dated June 26 [no year], and "A Little Story of a Basket," eight typed and double-spaced pages, n.d., McIlhenny Company and Avery Island, Inc., Archives; John Swanton to Mary Bradford, August 2, 1934, Mary Bradford Papers. Bradford also sent copies of the photograph to museums at Harvard and Hampton for inclusion with their Chitimacha collections. Donald Scott to Mary Bradford, July 31, 1934, Arthur Howe to Mary Bradford, September 10, 1934, Mary Bradford Papers.

54. Scott Stevens, "Cultural Mediations: Or How to Listen to Lewis and Clark's Indian Artifacts," *American Indian Culture and Research Journal* 31, no. 3 (2007): 181–202, quotation from 183. The fuller application of this integrationist approach to these particular objects can be found in Castle McLaughlin, *Arts of Diplomacy: Lewis and Clark's Indian Collection* (Cambridge, Mass.: Harvard University Press, 2003).

55. The advantage to encompassing all points of interaction has been effectively demonstrated, specifically for Navajo participation in the arts and

crafts market, in Bsumek, *Indian-Made*, and Wilkins, *Patterns of Exchange*. For the same kind of success with the study of Cherokee basketry, see Hill, *Weaving New Worlds* and "Marketing Traditions."

Chapter Two. *"We Have No Justice Here"*

1. Christine Paul to Mary Bradford, March 9, 1905, Mary Bradford Papers, McIlhenny Company and Avery Island, Inc., Archives, Avery Island, La.

2. Barbara A. Hail, "A House for the Beginning of Life," in *Gifts of Pride and Love: Kiowa and Comanche Cradles*, ed. Barbara A. Hail (Providence, R.I.: Haffenreffer Museum of Anthropology, Brown University, 2000), 17–39; Ruth B. Phillips, "Quilled Bark from the Central Great Lakes: A Transcultural History," in *Studies in American Indian Art: A Memorial Tribute to Norman Feder*, ed. Christian F. Feest (Seattle: University of Washington Press, 2001), 118–31; Jennifer Kramer, *Switchbacks: Art, Ownership, and Nuxalk National Identity* (Vancouver: University of British Columbia Press, 2006); Jerold S. Auerbach, *Explorers in Eden: Pueblo Indians and the Promised Land* (Albuquerque: University of New Mexico Press, 2006); Colette A. Hyman, *Dakota Women's Work: Creativity, Culture, and Exile* (St. Paul: Minnesota Historical Society Press, 2012).

3. Exhibit on Chitimacha Basketry, Chitimacha Museum, Chitimacha Tribe of Louisiana, Charenton, La.; Herbert T. Hoover, *Chitimacha People* (Phoenix: Tribal History Series, 1975), 54–57, 88; Robert A. Brightman, "Chitimacha," *Handbook of North American Indians. Volume 14: Southeast*, ed. Raymond Fogelson (Washington, D.C.: Smithsonian Institution, 2004), 649–50.

4. *New Orleans Daily Picayune*, April 24, 1894.

5. Daniel Browning to Hoke Smith, April 14, 1894, Box 436, Records of the Bureau of Indian Affairs, Central Classified Files, 1907–1939 (hereafter RBIA), Record Group 75, National Archives. Two years later, when the Louisiana Supreme Court was considering a case of attempted murder of a Tunica by another Tunica, Browning responded to an inquiry from associate justice Samuel D. McEnery by writing, "The Federal government does not have any jurisdiction over any Indians in Louisiana." Brian Klopotek, *Recognition Odysseys: Indigeneity, Race, and Federal Tribal Recognition Policy in Three Louisiana Indian Communities* (Durham, N.C.: Duke University Press, 2011), 41–46.

6. Donald Juneau, "The Light of Dead Stars," *American Indian Law Review*

11, no. 1 (1983): 1–55. As in other regions, state and federal courts had tried some Louisiana cases in which the right of Indians to sell their land was contested by conflicting non-Indian claimants. Although John Marshall's decision in *Johnson v. McIntosh* (1823), a case involving Illinois land, justified dispossession with damaging language about Indian inferiority, it did not dismiss altogether Indian sovereignty and title. It affirmed the federal government's exclusive or preemptive right to acquire Indian lands, denying Indians the freedom to sell them to another government or to any citizen of the United States. Tim Alan Garrison, *The Legal Ideology of Removal: The Southern Judiciary and the Sovereignty of Native American Nations* (Athens: University of Georgia Press, 2002), 87–102; N. Bruce Duthu, *American Indians and the Law* (New York: Viking Penguin, 2008), 69–75. For the most comprehensive study of *Johnson v. McIntosh*, see Blake A. Watson, *Buying America from the Indians: Johnson v. McIntosh and the History of Native Land Rights* (Norman: University of Oklahoma Press, 2012).

7. *New Orleans Daily Picayune*, December 10, 1896, January 3, 1897, March 21, 1897, January 8, 1898, March 9, 1898.

8. George Demarest to Chief John Paul, December 4, 1898, Chitimacha Papers, McIlhenny Company and Avery Island, Inc., Archives, Avery Island, La.

9. "Chetimaches and Their Land Claims," *New Orleans Daily Picayune*, June 11, 1899.

10. George A. Demarest to Chief John Paul, December 4, 1898, February 11, 1900, Chitimacha Papers.

11. Two decades ago, Melissa L. Meyer encouraged other historians to pay closer attention to the local variations in how dispossession of American Indian land and resources occurred and in how American Indians confronted U.S. policies. "'We Can Not Get a Living as We Used To': Dispossession and the White Earth Anishinaabeg, 1889–1920," *American Historical Review* 96 (April 1991): 368–94. My Chitimacha case study is pursued in that spirit.

12. *Chetimachas Indians v. Delhaye et al.*, Opinion of the Court overruling the Motion for a New Trial, April 2, 1900, U.S. Circuit Court, Eastern District of Louisiana, No. 12585, handwritten copy in Mary Bradford Papers. The federal judge ruling against the Chitimachas in this case, Charles Parlange, belonged to the planter class of south Louisiana and was a close associate of another wealthy and powerful planter-judge, U.S. Supreme Court Justice Edward Douglass White. Parlange was born into one of the oldest and wealthiest planter families in Louisiana and was raised on a ten thousand acre estate along False River. White grew up on his father's sugar plantation on Bayou Lafourche,

located within the ancient homeland of the Chitimachas. In the 1860s he and Parlange studied law together under New Orleans attorney Edward Bermudez and later became law partners in the Crescent City. Both men launched their political and professional careers literally on the streets of New Orleans, as members of the White League committed to restoring home rule and white supremacy, even if it took violent action (which it did). Appointed to the U.S. Supreme Court in 1894, partly as a way for President Grover Cleveland to remove from the Senate a leading opponent of tariff reduction, Edward White of course voted with the court's majority in *Plessy v. Ferguson* (1896). Although not usually associated with the Jim Crow South, another Supreme Court decision actually written by White had a profound impact on Indigenous people in every region of the nation. In *Lone Wolf v. Hitchcock* (1903), he declared that Congress possessed "plenary authority over the tribal relations of the Indians," including power to abrogate Indian treaty provisions when such action was "in the interest of the country and the Indians themselves." Historians have explored in depth how this ruling bolstered the federal government's assault on tribal sovereignty and have even shown how, through "Insular Case" decisions also written by Edward White, it influenced U.S. policy toward newly acquired territory in Caribbean and Pacific waters. Robert B. Highsaw, *Edward Douglass White: Defender of the Conservative Faith* (Baton Rouge: Louisiana State University Press, 1981), 20–41, 50–55, 170–77; William D. Reeves, *Paths to Distinction: Dr. James White, Governor E. D. White, and Chief Justice Edward Douglass White of Louisiana* (Thibodeaux, La.: Friends of the Edward Douglass White Historic Site, 1999); Blue Clark, *Lone Wolf v. Hitchcock: Treaty Rights and Indian Law at the End of the Nineteenth Century* (Lincoln: University of Nebraska Press, 1994), 70–104; Kevin Bruyneel, *The Third Space of Sovereignty: The Postcolonial Politics of U.S.-Indigenous Relations* (Minneapolis: University of Minnesota Press, 2007), 80–95.

13. W. A. Jones to E. A. Hitchcock, January 22, 1900, Mary Bradford Papers.

14. George Roth, "Federal Tribal Recognition in the South," in *Anthropologists and Indians in the New South*, ed. Rachel A. Bonney and J. Anthony Paredes (Tuscaloosa: University of Alabama Press, 2001), 49–70; Malinda Maynor Lowery, *Lumbee Indians in the Jim Crow South: Race, Identity, and the Making of a Nation* (Chapel Hill: University of North Carolina Press, 2010), 87–94; Theda Perdue, "The Legacy of Indian Removal," *Journal of Southern History* 78 (February 2012): 3–36; Mark Edwin Miller, *Claiming Tribal Identity: The Five Tribes and the Politics of Federal Acknowledgment* (Norman: University of Oklahoma Press, 2013), 30–40. The full scope of issues surrounding recognition has been

recently captured in Amy E. Den Ouden and Jean M. O'Brien, eds., *Recognition, Sovereignty Struggles, and Indigenous Rights in the United States: A Sourcebook* (Chapel Hill: University of North Carolina Press, 2013).

15. Christine Paul to Mary Bradford, December 29, 1901, Mary Bradford Papers; Mark R. Harrington, "Grievances of the Chitimacha Indians Living near Charenton, St. Mary Parish, Louisiana," enclosed in Harrington to Commissioner of Indian Affairs, May 19, 1908, Box 436, RBIA.

16. "An Indian Uprising: Desperate Battle between a Posse and a Tribe of Indians," *St. Mary Banner*, December 28, 1901.

17. "Battle with Indians Right in Louisiana: St. Mary Sheriffs Attempt to Arrest a Chetimache Indian for an Assault upon a Negro at Charenton. And Are Met with Resistance Which Precipitates Trouble, Two of the Tribe Being Killed, While Several Officers Are Desperately Wounded," *New Orleans Daily Picayune*, December 26, 1901.

18. *George A. Demarest et al. v. Paul Nelson et al.*, 1903 (No. 10,986), Louisiana District Court, Parish of St. Mary, St. Mary Parish Records, Franklin, Louisiana; Mary McIlhenny Bradford, untitled and undated notebook, Louisiana State University Museum of Natural Science; Emmet Alpha to Sara McIlhenny, February 4, 1913, Box 436, RBIA.

19. *Emmet Alpha v. Benjamin Paul et al.*, 1904–5 (No. 11,527), Louisiana District Court, Parish of St. Mary.

20. *New Orleans Daily Picayune*, September 5, 1899.

21. Clara Darden and Christine Paul to Mary Bradford, September 18, 1899, Mary Bradford Papers.

22. For more information about this particular effort, see Daniel H. Usner, "From Bayou Teche to Fifth Avenue: Crafting a New Market for Chitimacha Indian Baskets," *Journal of Southern History* 79 (May 2013): 360–72.

23. Edwin Alderman to Mary Bradford, August 31, 1903, Mary Bradford Papers.

24. S. M. McCowan to Mary Bradford, September 10, 1903, Mary Bradford Papers.

25. William A. Jones to Mary Bradford, October 24, 1903, Mary Bradford Papers.

26. Mary Bradford to William A. Jones, November 12, 1903, Mary Bradford to Robert Broussard, November 14, 1903, Robert Broussard to Mary Bradford, November 23, 1903, January 13, 1904 (with letter of December 29, 1903, from William A. Jones enclosed), Mary Bradford Papers.

27. Christine Paul to Mary Bradford, March 9, 1905, April 18, 1905, Mary Bradford Papers.

28. Sara Avery McIlhenny to Mr. Denégre, April 19, 1905, Mary Bradford Papers.

29. Moses Friedman to Robert G. Valentine, November 4, 1910, Box 436, RBIA.

30. Christine Paul to Mary Bradford, May 2, 1907, John Swanton to Mary Bradford, November 16, 1908, Mary Bradford Papers. For insight into contemporary ethnographic work at other Indian communities in the region, see Stephanie May de Montigny, "Chiefs, Churches, and 'Old Industries': Photographic Representations of Alabama-Coushatta and Coushatta Culture and Identity," *American Indian Culture and Research Journal* 32, no. 4 (2008): 1–40.

31. Christine Paul to Mary Bradford, March 1, 1908, March 14, 1908, April 8, 1908, Judge A. C. Arthur to Mary Bradford, March 6, 1908, Mary Bradford Papers.

32. Mark Harrington to Commissioner of Indian Affairs, May 19, 1908, Draft of Acting Commissioner of Indian Affairs W. C. Farrabee's unsent letter to the Governor of Louisiana, May 29, 1908, W. C. Farrabee to Mark Harrington, June 2, 1908, Box 436, RBIA.

33. Emmet Alpha to Sara McIlhenny, February 4, 1913, Box 436, RBIA.

34. *Louisiana Planter and Sugar Manufacturer* 2, no. 18 (May 4, 1889): 212; ibid., 2, no. 19 (May 11, 1889): 224; ibid., 2, no. 24 (June 15, 1889): 285; *The Southern Reporter*, 31 (1902): 1019–23, 10; ibid., 46 (1908): 114–17; ibid., 53 (1911): 852–56; ibid., 62 (1913): 138–40.

35. *Louisiana Planter and Sugar Manufacturer* 43, no. 24 (December 11, 1909): 375; Julana M. Senette, *St. Mary Parish: Images of America* (Charleston, S.C.: Arcadia, 2012), 2, 17; Roger Emile Stouff, *Native Waters: A Few Moments in a Small Wooden Boat* (Jeanerette, La.: Shadowfire, 2012), 113–14.

36. Christine Paul to Mary Bradford, November 26 and December 19, 1906, January 21, 1907, Mary Bradford Papers; Mary Bradford to Christine Paul, December 4, 1906, Chitimacha Papers.

37. Delphine Stouff to Mary Bradford, December 4, 1906, Christine Paul to Mary Bradford, April 8, 1908, Mary Bradford Papers; Sara McIlhenny to Christine Paul, January 31, 1907, Mary Bradford to Christine Paul, October 26, 1907, Chitimacha Papers; Bernard, *Tabasco*, 141.

38. Delphine Stouff to Mark R. Harrington, January 22, 1912, Box 436, RBIA.

39. Arthur Parker to Cato Sells, January 28, 1914, Box 436, RBIA; M. R. Harrington, "Grievances of the Chitimacha Indians Living Near Charenton, St. Mary Parish, Louisiana," *Quarterly Journal of the Society of American Indians* 1 (January–March 1913): 61–63; Mark R. Harrington to Matthew K. Sniffen, January 29, 1914, Folder 4, Box 63, Incoming Correspondence, Indian Rights Association Records, Historical Society of Pennsylvania, Philadelphia. For analysis of how the Society of American Indians more generally mobilized white interest in Indian culture for political ends, see Michelle Wick Patterson, "'Real' Indian Songs: The Society of American Indians and the Use of Native American Culture as a Means of Reform," *American Indian Quarterly* 26 (Winter 2002): 44–66.

40. Pauline Paul to Moses Friedman, January 10, 1914, Christine Paul to H. B. Peairs, December 29, 1913, Box 436, RBIA.

41. William Brewster Humphrey to James H. Dillard, June 30, 1913, Box 436, RBIA.

42. Samuel Brosius to Matthew Sniffen, January 29, 1914, Folder 4, Box 63, Incoming Correspondence, Indian Rights Association Records; John McIlhenny to Cato Sells, January 31, 1914, February 3, 1914, Box 436, RBIA.

43. Charles Dagenett to Mrs. Sidney Bradford, January 26, 1914, Sara McIlhenny to Charles Dagenett, January 31, 1914, Box 436, RBIA.

44. Samuel Brosius to Matthew K. Sniffen, February 23, 1914, Samuel Brosius to Mrs. John Markoe, February 24, 1914, Samuel Brosius to Matthew Sniffen, March 11, 1914, March 12, 1914, Folder 2, Box 64, Incoming Correspondence, Indian Rights Association Records.

45. Walter Guion to Attorney General James C. McReynolds, March 17, 1914, Box 436, RBIA; Charles J. Kappler, comp. and ed., *Indian Affairs: Laws and Treaties*, 7 vols. (Washington, D.C.: Government Printing Office, 1904–72), 4, 63.

46. Sara McIlhenny to Christine Paul, January 3, 1915, Chitimacha Papers; Cato Sells to Robert Broussard, February 20, 1914, Box 436, RBIA; Indian Appropriations Bill, Report No. 1022, *Senate Reports (Public)*, vol. 1, *63d Congress, 3d Session, December 7, 1914–March 4, 1915* (Washington, D.C.: Government Printing Office, 1915), 20–22; Kappler, ed. *Indian Affairs: Laws and Treaties*, 4, 63. Section 7 of the annual Indian appropriations act of May 18, 1916, allocated $1,500 "For clearing the title owned or possessed by the Chettimanchi Band of Indians of Louisiana" provided that "the Secretary of Interior may in his discretion, require that the legal title to all property purchased, or the

title to which is to be cleared, with the funds hereby appropriated shall be in the name of the United States, for the use and benefit of the Indians." It is worth noting that, although under somewhat different circumstances but not without a similar degree of Indian initiative, other southern Indian communities were receiving federal recognition during these same years. In 1911 the U.S. government began purchasing land and establishing an agency for the Seminoles in south Florida. Seven years later, a Choctaw Indian agency was established at Philadelphia, Mississippi.

47. Sara McIlhenny to Cato Sells, August 15, 1919, Box 437, RBIA.

48. Chitimacha women's strategic use of assistance from well-to-do white women to protect their communities against destruction resembled what Siobhan Senier calls an "alternative aesthetic" in her study of literature produced by Indian women over the late nineteenth and early twentieth centuries. *Voices of American Indian Assimilation and Resistance: Helen Hunt Jackson, Sarah Winemucca, and Victoria Howard* (Norman: University of Oklahoma Press, 2001), 3–4.

49. L. G. Moses, *Wild West Shows and the Images of American Indians, 1883–1933* (Albuquerque: University of New Mexico Press, 1996); Philip Deloria, *Playing Indian* (New Haven: Yale University Press, 1998); Clyde Ellis, "Five Dollars a Week to Be 'Regular Indians': Shows, Exhibitions, and the Economics of Indian Dancing, 1880–1930," in *Native Pathways: American Indian Culture and Economic Development in the Twentieth Century*, ed. Brian Hosmer and Colleen O'Neill (Boulder: University Press of Colorado, 2004), 184–208; Paige Raibmon, *Authentic Indians: Episodes of Encounter from the Late-Nineteenth-Century Northwest Coast* (Durham, N.C.: Duke University Press, 2005); Brad D. Lookingbill, *War Dance at Fort Marion: Plains Indian War Prisoners* (Norman: University of Oklahoma Press, 2006); Jane E. Simonsen, *Making Home Work: Domesticity and Native American Assimilation in the American West, 1860–1919* (Chapel Hill: University of North Carolina Press, 2006); Trudy Nicks and Ruth B. Phillips, "'From Wigwam to White Lights': Princess White Deer's Indian Acts," in *Three Centuries of Woodlands Indian Art: A Collection of Essays*, ed. J. C. H. King and Christian F. Feest (Altenstadt: ZKF Publishers, 2007), 144–60; John W. Troutman, *Indian Blues: American Indians and the Politics of Music, 1879–1934* (Norman: University of Oklahoma Press, 2009).

50. Frederick E. Hoxie, "Exploring a Cultural Borderland: Native American Journeys of Discovery in the Early Twentieth Century," *Journal of American History* 79 (December 1992): 969–95, quotes from 970 and 976.

Chapter Three. "Language of the Wild Things"

1. Caroline Dormon to John Collier, n.d., Document number 179, Microfilm reel 35, John Collier Papers, 1922–1968, James E. Walker Library, Middle Tennessee State University, Murfreesboro, Tenn.

2. Caroline Dormon, "The Last of the Cane Basket Makers," *Holland's, the Magazine of the South*, October 1931, 13, 66. For information about the magazine, see Karen Collins, "Holland's Magazine," *Handbook of Texas Online* (http://www.tshaonline.org/handbook/online/articles/edh01), accessed July 24, 2013, published by the Texas State Historical Association.

3. "Only Woman in Forestry Active Federal Worker," *New Orleans Times-Picayune*, October 8, 1922. In significant ways, Caroline Dormon's career in forest conservation resembled that of Mira Lloyd Dock, an older woman who had become a leader in forestry education and conservation in Pennsylvania, as well as improvement in rural and urban landscapes. See Susan Rimby, *Mira Lloyd Dock and the Progressive Era Conservation Movement* (University Park: Pennsylvania State University Press, 2012).

4. Donald M. Rawson, "Caroline Dormon: A Renaissance Spirit of Twentieth-Century Louisiana," *Louisiana History* 24 (Spring 1983): 121–39; Fran Holman Johnson, *"The Gift of the Wild Things": The Life of Caroline Dormon* (Lafayette: Center for Louisiana Studies, 1990); Benay Blend, "'I Was . . . the Very Heart of Wildness': Caroline Dormon, Naturalist and Preservation Activist," *Southern Quarterly* 35 (Fall 1996): 69–73; Patricia T. Bates, Karen Cole, Fran Holman, and Barbara Allen, "The Heart of Wildness," *Louisiana Cultural Vistas* 8 (Winter 1997–98): 66–72; Dayna Bowker Lee, "Caroline Dormon (1888–1971): Louisiana Cultural Conservator," in *Louisiana Women: Their Lives and Times*, ed. Janet Allured and Judith F. Gentry (Athens: University of Georgia Press, 2009).

5. Pauline Paul to Caroline Dormon, November 4, 1931, Folder 1436, Caroline Dormon Collection, Cammie Henry Research Center, Watson Library, Northwestern State University of Louisiana, Natchitoches.

6. Christine Paul to Caroline Dormon, January 1, 1930, Pauline Paul to Caroline Dormon, November 24, 1930, Folder 1345, Dormon Collection; Pauline Paul to Caroline Dormon, August 8, 1931, Folder 1346, Dormon Collection.

7. Christine Paul to Caroline Dormon, January 17, 1932, April 24, 1932, Folder 1346, Dormon Collection.

8. Christine Paul to Caroline Dormon, July 21, 1936, Folder 1348, Dormon Collection.

9. Sara McIlhenny to Christine Paul, February 10, 1932, Chitimacha Papers; Donald Scott to Mary Bradford, August 17, 1932, Mary Bradford Papers, McIlhenny Company and Avery Island, Inc., Archives, Avery Island, La.

10. Mary Bradford to Donald Scott, July 24, 1934, Accession File 32-18-10/30, 32, Peabody Museum of Archaeology and Ethnology, Harvard University, Cambridge, Mass.; Sara McIlhenny to Christine Paul, March 18, 1937, Mary Bradford to Christine Paul, December 15, 1939, Chitimacha Papers.

11. John Swanton to Caroline Dormon, March 16, 1929, Folder 1358, Dormon Collection; John Swanton to Caroline Dormon, n.d., Folder 1357, Dormon Collection; John Swanton to Caroline Dormon, January 14, 1930, May 2, 1930, Folder 1359, Dormon Collection.

12. John R. Swanton, "Indian Language Studies in Louisiana," in *Explorations and Field-Work of the Smithsonian Institution in 1930* (Washington, D.C.: Smithsonian Institution, 1931), 195.

13. For details regarding Dormon's work in archaeology and the DeSoto Commission, see Alicia Trissler, "Caroline Dormon and Louisiana Archaeology of the 1930s," MA thesis, Northwestern State University of Louisiana, 1994; and Johnson, *Gift of the Wild Things*, 79–88. Edwin A. Lyon, *A New Deal for Southeastern Archaeology* (Tuscaloosa: University of Alabama Press, 1996) is a comprehensive study of archaeological work across the South during these years.

14. Bonnye E. Stuart, *Remarkable Louisiana Women* (Guilford, Conn.: Globe Pequot Press, 2009), 101–34.

15. Ada Jack Carver, "Redbone," *Harper's Magazine* 150 (February 1925): 257–70; Lyle Saxon, ed., *Louisiana: A Guide to the States* (New York: Hastings House, 1941). For this WPA guide's detailed description of the Chitimacha reservation in particular, see pp. 425–27.

16. Duane Gage, "William Faulkner's Indians," *American Indian Quarterly* 1 (Spring 1974): 27–33; Howard C. Horsford, "Faulkner's (Mostly) Unreal Indians in Early Mississippi History," *American Literature* 64 (June 1992): 311–30; D'Arcy McNickle, *Indian Man: A Life of Oliver La Farge* (Bloomington: Indiana University Press, 1971), 44–93.

17. Caroline Dormon, "Southern Personalities: Lyle Saxon," *Holland's, the Magazine of the South* (January 1931): 26, 65. For Dormon's relationship with Saxon, see James W. Thomas, *Lyle Saxon: A Critical Biography* (Birmingham, Ala.: Summa, 1991), 124–32 and Chance Harvey, *The Life and Selected Letters of Lyle Saxon* (Gretna, La.: Pelican, 2003), 79–80, 105, 251–52.

18. Caroline Dormon to Carmeline Henry, April 20, 1936, Folder 13, Box 1,

Cammie Henry Papers, 1929–1946, Historic New Orleans Collection, New Orleans.

19. John Swanton to Caroline Dormon, July 13, 1932, Folder 1365, Dormon Collection; Morris Swadesh to Caroline Dormon, July 24, 1932, Folder 1346, Dormon Collection.

20. Frances Densmore, "Studying Indian Music in the Gulf States," in *Exploration and Field-Work of the Smithsonian Institution in 1933* (Washington, D.C.: Smithsonian Institution, 1934), 57–59; Densmore, "A Search for Songs among the Chitimacha Indians in Louisiana," Smithsonian Institution Bureau of American Ethnology Bulletin 133, *Anthropological Papers*, no. 19 (Washington, D.C.: U.S. Government Printing Office, 1943), 1–15.

21. "The Origin of Basket Weaving" (Story A13) and "How I Learned to Weave" (Story B18), Morris Swadesh, Field Notes on Chitimacha 1930–34, Committee on Native American Languages, American Philosophical Society, Philadelphia.

22. Caroline Dormon to Mary Haas Swadesh, August 26, 1933, Correspondence, Box 1, Mary Rosamond Haas Papers, 1930–1996, American Philosophical Society, Philadelphia.

23. Mary Haas Swadesh to Caroline Dormon, August 6, 1933, Folder 1479, Dormon Collection; Caroline Dormon to Mary Haas, August 26, 1933, January 26, 1937, February 3, 1937, January 17, 1938, June 18, 1938, Box 1, Mary Rosamond Haas Papers; Mary Haas to Caroline Dormon, January 30, 1937, February 28, 1937, November 13, 1937, January 26, 1938, July 21, 1938, Box 1, Mary Rosamond Haas Papers. Mary Haas and Morris Swadesh divorced in 1937, "though still the best of friends," as she informed Dormon in the November 13 letter; Haas restored her maiden name during that year.

24. Caroline Dormon, *Wild Flowers of Louisiana* (Garden City, N.Y.: Doubleday, Duran, 1934), 42.

25. Caroline Dormon, "Caddo Pottery," *Art and Archaeology* 35 (March–April 1934): 59–68, quote from 68.

26. John R. Swanton, "Notes on the Cultural Province of the Southeast," *American Anthropologist*, n.s., 37 (July–September 1935): 373–85, quote from 378.

27. Charles Boatner to the Office of Indian Affairs, January 10, 1922, December 14, 1931, Box 437, Records of the Bureau of Indian Affairs, Central Classified Files, 1907–1939 (hereafter RBIA); Charles Boatner to Benjamin Paul, March 3, 1924, Chitimacha Papers.

28. Benjamin Paul to E. B. Meritt, April 29, 1922, Box 437, RBIA.

29. J. Henry Scattergood to Caroline Dormon, August 30, 1929, Folder 1354, Dormon Collection.

30. Alex P. Dardin to Charles J. Rhoads, March 14, 1932, Benjamin Paul to Office of the Treasurer, December 28, 1932, Charles J. Rhoads to Benjamin Paul, January 16, 1933, Memorandum for Land Allotments, June 29, 1933, Box 437, RBIA.

31. Alice M. Peters to Charles J. Rhoads, August 12, 1932, Central Correspondence File 68776-1931-800, General Services, Record Group 75, National Archives. Correspondence over establishing a school at Charenton is detailed in Brian Klopotek, *Recognition Odysseys: Indigeneity, Race, and Federal Tribal Recognition Policy in Three Louisiana Indian Communities* (Durham, N.C.: Duke University Press, 2011), 320. For valuable analysis of the Jena Choctaws' struggle for education in Louisiana, see Klopotek's more recent essay, "Indian Education under Jim Crow," in *Indian Subjects: Hemispheric Perspectives on the History of Indigenous Education*, ed. Brenda J. Child and Brian Klopotek (Santa Fe, N.Mex.: School for Advanced Research Press, 2014), 48–72.

32. George Roth, "Federal Tribal Recognition in the South," in *Anthropologists and Indians in the New South*, ed. Rachel A. Bonney and J. Anthony Parades (Tuscaloosa: University of Alabama Press, 2001), 49–70, quote from 55.

33. John Collier to Caroline Dormon, September 6, 1935, Folder 1435, Dormon Collection.

34. Christine Paul to Caroline Dormon, January 18, 1936, Folder 1348, Dormon Collection.

35. Caroline Dormon to Allen J. Ellender, August 5, 1937, Folder 1436, Dormon Collection.

36. Daniel H. Usner, "From Bayou Teche to Fifth Avenue: Crafting a New Market for Chitimacha Indian Baskets," *Journal of Southern History* 79 (May 2013): 351–55.

37. Nancy Mayborn Peterson, *Walking in Two Worlds: Mixed-Blood Indian Women Seeking Their Path* (Caldwell, Idaho: Caxton Press, 2006), 183–202; Karen J. Blair, *The Torchbearers: Women and Their Amateur Arts Associations in America, 1890–1930* (Bloomington: Indiana University Press, 1994), 55, 62; T. H. Watkins, *Righteous Pilgrim: The Life and Times of Harold L. Ickes, 1874–1952* (New York: Henry Holt, 1990), 201–5, 270–71.

38. Caroline Dormon, "Indian Welfare" (typed draft with handwritten editing), Marie Hester to Caroline Dormon, September 17, 1938, Anna Kelton Wiley to State Chairman of Indian Welfare, November 18, 1938, Folder 653, Dormon Collection.

39. Olivia M. [Mrs. A. R.] Lacy to Mrs. John Caffery, December 15, 1937, Folder 18, Box 2, and Mrs. John Caffery, "Indians in Louisiana" (handwritten and typed copies), Folder 7, Box 6, John Murphy Caffery Papers, 1817–1960, Acadiana Manuscripts Collection, Edith Garland Dupré Library, University of Louisiana at Lafayette.

40. E. Carson Ryan, Memorandum to Mr. Monahan, October 10, 1934, Central Classified Files 806-17606-1935, Record Group 75, National Archives.

41. Edna Groves to W. W. Beatty, January 17, 1938, Central Classified Files 806-3844-1937, Record Group 75, National Archives. Willard W. Beatty's vision for the Indian Service's nearly four hundred day schools in operation by the end of the 1930s was forcefully stated in "Uncle Sam Develops a New Kind of Rural School," *Elementary School Journal* 41 (November 1940): 185–94.

42. Christine Paul to Caroline Dormon, January 14, 1938, Folder 1349, Dormon Collection.

43. Sarah H. Hill, *Weaving New Worlds: Southeastern Cherokee Women and Their Basketry* (Chapel Hill: University of North Carolina Press, 1997), 283–302; Joshua S. Haynes, "Constructing Authenticity: The Indian Arts and Crafts Board and the Eastern Band of Cherokees, 1935–1985," *Native South* 3 (2010): 1–38.

44. Harvey Meyer to John Collier, December 26, 1939, Central Classified File 806-446-1940, Record Group 75, National Archives; Joseph Lucia, "Empty Chairs at Graduation: Louisiana Indians Leave for War before Diplomas Are Given at Charenton," *Times-Picayune New Orleans States Sunday*, June 14, 1942.

45. *The Problem of Indian Administration: Report of a Survey Made at the Request of Honorable Hubert Work, Secretary of the Interior, and Submitted to Him, February 21, 1928*, Institute for Government Research Studies in Administration, no. 17 (Baltimore: Johns Hopkins University Press, 1928), 532.

46. Report of the Committee on Indian Arts and Crafts to Secretary of Interior Harold Ickes, September 1934 (14 pages), Document number 529, Microfilm reel 30, John Collier Papers. Major studies of this change in the treatment of Indian arts and crafts include Robert Fay Schrader, *The Indian Arts and Crafts Board: An Aspect of New Deal Indian Policy* (Albuquerque: University of New Mexico Press, 1983); Susan Labry Meyn, *More Than Curiosities: A Grassroots History of the Indian Arts and Crafts Board and Its Precursors, 1920–1942* (Lanham, Md.: Lexington Books, 2001); and Jennifer McLerran, *A New Deal for Native Art: Indian Arts and Federal Policy, 1933–1943* (Tucson: University of Arizona Press, 2009). For scrutiny of the educational agenda in particular, see

John J. Laukaitis, "Indians at Work and John Collier's Campaign for Progressive Educational Reform, 1933–1945," *American Educational History Journal* 33, no. 2 (2006): 97–105; and Joseph Watras, "Progressive Education and Native American Schools, 1929–1950," *Educational Foundations* 18 (Summer–Fall 2004): 81–104.

47. W. Jackson Rushing, *Native American Art and the New York Avant-Garde: A History of Cultural Primitivism* (Austin: University of Texas Press, 1995); Wanda M. Corn, *The Great American Thing: Modern Art and National Identity, 1915–1935* (Berkeley: University of California Press, 1999).

48. Ruth Seinfel, "Indian Art as Art, Not as Ethnology, Miss White's Dream," *New York Evening Post*, December 1, 1931; "Indian Tribal Arts Exhibition Starts on Long Tour of Nation," *Art Digest*, December 15, 1931, 32; John Sloan and Oliver La Farge, *Introduction to American Indian Art to Accompany the First Exhibition of American Indian Art Selected Entirely with Consideration of Esthetic Value*, 2 vols. (New York: Exposition of Indian Tribal Arts, 1931), 1:1.

49. Dolly Sloan to Elizabeth White, May 5, 1932, May 21, 1932, Box 3, Amelia Elizabeth White Papers, Catherine McElvain Library, School for Advanced Research, Santa Fe; Packing List of Materials Returned to Miss A. E. White, Santa Fe, N.M. by the Exposition of Indian Tribal Arts, Inc., 578 Madison Avenue, New York, n.d., Box 24, Amelia Elizabeth White Papers; Catalogue of the Exposition of Indian Tribal Arts, Inc., Grand Central Art Galleries, 15 Vanderbilt Avenue, New York City, December 1 to 24, 1931, Exposition of Indian Tribal Arts, Catalogs, Organizational Records, Box 41, John Sloan Collection, Helen Farr Sloan Library and Archives, Delaware Art Museum, Wilmington.

50. Schrader, *Indian Arts and Crafts Board*, 163–98, 223–41.

51. Frederic H. Douglas and Rene D'Harnoncourt, *Indian Art of the United States* (New York: Museum of Modern Art, 1941), 118, 123–26.

52. Willard W. Beatty to Heloise Faye Delahoussaye, May 12, 1938, Central Classified File 806-38014-1937, Record Group 75, National Archives.

53. Caroline Dormon to Clarence Webb, October 16, 1945, November 7, 1945, Folder 2, Clarence H. Webb Collection, Cammie Henry Research Center, Watson Library, Northwestern State University of Louisiana, Natchitoches; Webb to Dormon, December 20, 1945, Folder 1478, Dormon Collection.

54. Caroline Dormon to Clarence Webb, December 4, 1945, Folder 2, Webb Collection.

55. Pauline Paul to Caroline Dormon, January 1, 1946, enclosed in Caroline Dormon to Clarence Webb, January 7, 1946, Folder 3, Webb Collection.

56. Sara M. Evans, *Born for Liberty: A History of Women in America*, 2nd ed. (New York: Simon and Schuster, 1997), 205–6.

57. Schrader, *Indian Arts and Crafts Board*, 140–42; Patricia Loughlin, *Hidden Treasures of the American West: Muriel H. Wright, Angie Debo, and Alice Marriott* (Albuquerque: University of New Mexico Press, 2005), 111–25; Melissa Jayne Fawcett, *Medicine Trail: The Life and Lessons of Gladys Tantaquidgeon* (Tucson: University of Arizona Press, 2000). For Marriott's work with Choctaw weavers in Oklahoma, see Alice Marriott, *Greener Fields: Experiences among the American Indians* (New York: Thomas Y. Crowell, 1953), 178–88.

58. Caroline Dormon to the David McKay Company, June 23, 1943, Folder 978, Dormon Collection.

59. Caroline Dormon, *Southern Indian Boy* (Baton Rouge: Claitor's Book Store, 1967).

60. William Lanier Hunt, "Southern Gardens," undated copy of column in Folder 951, Dormon Collection.

Evans, Sara M., 22, 74
Exposition of Indian Tribal Arts (New York City, 1931), 71

Farrabee, William C., 43
Faulkner, William, 58–59
federal government Indian policy: assimilation, 9, 28, 70; culture and education, 39–40, 42, 65, 70; Indian New Deal, 55, 65, 68; land rights, 23, 30–34, 49–50, 64, 91–92n6, 92–93nn11–12, 96n46; tribal recognition, 3, 19–20, 41, 45–46, 57, 64–66, 92–93n12
Federal Writers Project (Works Progress Administration), 58
Fortier, Alcée, 4
Friedman, Moses, 46

Gardiner, Catherine Marshall, 20–21
Gatschet, Albert, 3
General Federation of Women's Clubs, 12, 67
Golden Gate International Exposition (San Francisco World's Fair, 1939), 71–72
Great Depression, 56, 63
Groves, Edna, 68–69
Guion, Walter, 48

Haas, Mary, 59–61
handicrafts: artistic significance, 4, 21, 26, 30, 62, 67, 69–72; economic and political value to tribes, 2–4, 27, 32–33, 46, 50–51, 68–70, 76; ethnographic study of, 62–63; movement and interaction, 2–3, 25–26, 28; patronage of, 2–3, 8–9, 11, 16, 33, 84n13, 90n55. *See also* basketry; cultural objects
Harrington, Gwyneth Browne, 74
Harrington, Mark Raymond, 20, 42, 43, 45–46
Harris, T. H., 65
Hartley, Marsden, 70

Henry, Carmeline Garrett, 58–59
Heye, George Gustav, 20, 42, 88n41
Hill, Sarah H., 2, 84n13
Hitchcock, Ethan, 33
Holm, Tom, 9
Hoxie, Frederick, 50
Humphrey, William Brewster, 46
Hunt, William Lanier, 75
Hunter, Clementine, 58
Hutchinson, Elizabeth, 85n17

Ickes, Anna, 67
Ickes, Harold, 67
Indian Art of the United States (Museum of Modern Art, 1941), 71–72
Indian Arts and Crafts Act (1935), 70
Indian Arts and Crafts Board, 69, 71, 74
Indian Arts Fund (Santa Fe), 71
Indian Industries League, 12
Indian Music Programs (R. C. Lawson), 67
Indian reform movement, 9, 11–13, 18–19, 55, 65–68, 70
Indian Reorganization Act (1934, Indian New Deal), 55, 65, 68
Indian Rights Association, 46, 47–48
Indian Trade and Intercourse Act (1790), 31
Indian Tribes of the Lower Mississippi Valley (Swanton), 20
"Indian Uprising" (*St. Mary Banner*, Franklin, La.), 35
Indian Work (Usner), 83n2
industrialization and urbanization, 9, 19
Institute of Government Research, 70

Jim Crow, 65, 92–93n12
Johnson v. McIntosh (1823), 31
Johnston, Margaret Avery, 8, 11, 22
Johnston, William Preston, 5
Jones, William A., 33, 40
Journeycake, Charles, 67

King, Grace, 4, 11
Kinsey, Alberta, 58